IMAGES
of America

YORBA LINDA

IMAGES
of America

YORBA LINDA

Cindy Tino-Sandoval

ARCADIA
PUBLISHING

Published by Arcadia Publishing
Charleston SC, Chicago IL, Portsmouth NH, San Francisco CA

Printed in the United States of America

Library of Congress Catalog Card Number: 2004113948

For all general information contact Arcadia Publishing at:
Telephone 843-853-2070
Fax 843-853-0044
E-mail sales@arcadiapublishing.com
For customer service and orders:
Toll-Free 1-888-313-2665

Visit us on the Internet at www.arcadiapublishing.com

CONTENTS

ACKNOWLEDGMENTS

As an Orange County native who was born in the late 1950s, I grew up watching what were once primarily agricultural communities transform into suburbs and, ultimately, busy metropolises. Yorba Linda, especially in the 1960s, was my family's favorite destination for a Sunday drive in the country, with a stop at nearby Fullerton's Currie's Ice Cream along the way. Yorba Linda was the cherished late bloomer among our communities, a place where orange groves still predominated the rolling landscape and family farms remained, although no longer in abundance. I have long felt an affinity for places that retain their rural character, and thus I am grateful for this opportunity to help preserve Yorba Linda memories in an easily accessible format. I would like to thank Mary Ruth Erickson, who is surely the grande dame of Yorba Linda history, for sharing with me her scholarly, heartfelt interest in her community and her generous spirit. In addition, I would like to thank Dot Wallingsford and the Yorba Linda Heritage Society at the Bixby-Bryant Ranch House, as well as the Orange County Archives, especially archivists Phil Brigandi and Chris Jepsen. Thanks also to the Richard Nixon Presidential Library and Birthplace, Steve Rudometkin and the City of Yorba Linda, Jim and Carol Tice, David and Patty Newell, and Judy Robertson. Special thanks are also due to Sid and Alice Munger for their personally guided tours, local lore, and friendship. I would also like to thank the Classic Cruisers of North Orange County, whose events benefit underprivileged children. Jim Granitto and the Yorba Linda Public Library have been indispensable for their guidance and photo archives. Last but not least, I would like to thank Bob Blankman and the First American Corporation. I dedicate this book to the memory of Bob's wife, the late Barbara Blankman, whose service as First American's librarian was surely a labor of love.

INTRODUCTION

Yorba Linda's known human history began with local Native Americans, perhaps as long ago as four millennia. Around 1771, Spanish missionaries named ancestors of these people Gabrielinos after the Mission San Gabriel, one of two important links between Monterey to the north and San Diego to the south. After exposure to European disease and abuses, many Indians affiliated with the missions for food and shelter in exchange for their labor and baptism. This Spanish/Indian interdependency continued long after the missionaries departed, when the Indians joined the many ranchos into which their land had been divided. In the 1850s, secularization and civil administration of mission lands by the Mexican government effectively ended the mission era.

Jose Antonio Yorba was part of a 1769 Spanish expedition from San Diego to Monterey, led by Gasper de Portola. A member of the military guard known as "leatherjackets," Yorba became familiar with the California landscape during his service at several Spanish outposts over the next 40 years. He retired in 1810 and, along with his nephew Juan Pablo Peralta, petitioned the king of Spain for a 62,516-acre land grant. The resulting Rancho Santiago de Santa Ana represented a massive slice of present-day Orange County, beginning at the east bank of the Santa Ana River and stretching from the Santa Ana mountains to the ocean. It was 6 miles across at its widest point and 25 miles long. Yorba's hacienda was located in what is now the city of Orange. He died in 1825 and was buried at Mission San Juan Capistrano.

Jose Antonio's third son, Bernardo Yorba, requested a grant of his own in 1834. In 1823, Mexico won its independence from Spain, making Don Bernardo's a Mexican land grant. Bernardo's 13,328-acre Rancho Cañon de Santa Ana (Canyon of Saint Anne) included what is now Yorba Linda. His impressive adobe overlooked the Santa Ana River and is estimated to have contained 50 to 100 rooms. The rancho was self-sufficient and employed a butter-and-cheese man who also oversaw the milking, two leather tanners, gardeners, dressmakers, a jeweler, two laundresses, a winemaker, a blacksmith, a baker, a plasterer, and a carpenter—as well as those who worked under them all. Whatever the rancho did not produce was procured via trade with ships operating out of the present-day Newport Beach area and the now dry Anaheim Bay. The site of this remarkable hacienda is now marked by a simple monument at the corner of Esperanza Road and Echo Hill Lane, at the entrance to a residential development. The original adobe was last owned by Samuel Kraemer, who was married to Angelina Yorba. Kraemer offered it, and the acre it stood upon, to the county as a gift. The county, however, demanded more acreage, and Kraemer, fed up with vandalism at the site, had it razed in 1926.

The Yorba Cemetery still stands on a hill in Woodgate Park, just west of the hacienda. Don Bernardo died in 1858 and was buried in Los Angeles. In 1923, his body was returned to the rancho cemetery.

A great flood in 1861–1862 drowned thousands of cattle and was followed by a two-year drought, which further decimated the land and the herds. In 1868, Yorba ranch lands were subsequently divided among over 100 descendants and claimants before eventually being traded, sold, or lost in legal disputes to the hands of developers. Attorneys given land in lieu of monetary payments included A.B. Chapman and Andrew Glassell, who cofounded the city of Orange.

Rancher John Bixby arrived on the scene in 1875, purchased a large swath of the former Yorba property, and called it Rancho Santa Ana. Bixby died in 1887, and by 1925 his daughter, Susanna Bixby Bryant, had become sole owner of the ranch. An avid gardener, Susanna was knowledgeable of native plants and created the 200-acre Rancho Santa Ana Botanic Garden. The garden was relocated to Claremont College four years after Susanna's death, and only a tiny representation of it remains at the ranch house, near Gypsum Canyon Road and La Palma. This structure, built in 1916 for the rancho foreman, is the last remaining structure. It is open to the public and now houses the Yorba Linda Heritage Museum.

Nearly concurrent with Bixby's land purchase were transfers made to family members, including Trinidad Yorba, Teodosio Yorba, and Francisco Yorba de Vejar. These lands were then sold on January 5, 1907, to Maurice Rey—who sold them five days later to Jacob Stern of Fullerton. In 1908, Stern sold the land to the Janss Investment Company, and thus began the agricultural "pioneer" period in Yorba Linda history. By 1909, Janss had completed town-site and acreage plans for development. Thus, a great familial land and cultural dynasty arose and declined in less than 75 years, but its legacy enriched the community that followed.

The Janss Investment Company energetically marketed Yorba Linda as a paradisiacal "frostless belt" for the growing of citrus and avocados, where "the rainfall is generous and the irrigation supply is ample." Pioneer farmers who purchased land for around $250 per acre included Frank and Hannah Nixon, who arrived and planted lemons in 1912. Richard Nixon was born in the family home on January 9, 1913. It has been fully restored and is open to the public as part of the Richard Nixon Presidential Library, which was dedicated in 1991.

Other "first families" of Yorba Linda included the Corbits, Marshburns, Kelloggs, Bartons, Shooks, Dobashis, Whedons, and Wests. Eldo West's daughter, Jessamyn, became a well-known writer of California historical fiction. Although the West house was destroyed in an arson fire several years ago, the site is marked by Jessamyn West Park on Yorba Linda Boulevard. The Dobashi family arrived in 1910 and remained the only Japanese family in Yorba Linda until 1945. The family farmed some 400 acres until their confinement in a "relocation center" at Santa Anita Racetrack in April of 1942. Each of these families, and many more, made their own unique contributions to agriculture, commerce, and community development.

Between 1910 and 1920, Yorba Linda's population increased tenfold to 350 before truly booming in the 1960s when groves began to give way to suburban subdivisions. By the time of its incorporation in 1967, Yorba Linda was truly "on the map" with nearly 12,000 residents. A mere 13 years later, that number had grown to around 30,000. Today, Yorba Linda is a thriving, well-planned community of 62,678 that is both cosmopolitan and rural, with small working farms and big businesses side-by-side. Outdoor recreation is popular on the many walking and hiking trails, as well as the 100 miles of horse trails and three state-of-the-art equestrian arenas built by the City. Yorba Linda also boasts three country clubs, including the sparkling new Black Gold Golf Club in the foothills north of Old Town. Yorba Linda has indeed fulfilled its nickname from the 1960s as "The Land of Gracious Living."

One

FROM RANCHO TO COMMUNITY

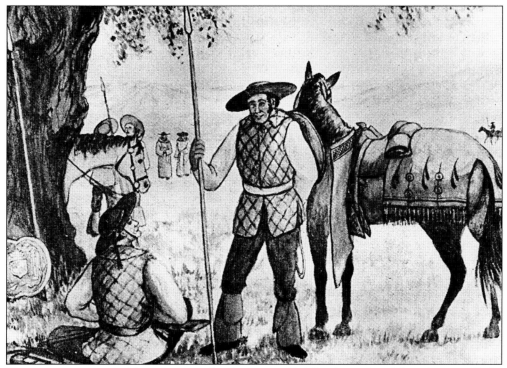

These men were not soldiers, but armed volunteers called "leatherjackets." Jose Antonio Yorba wore a uniform like this as part of the Spanish Guard, which escorted Junipera Serra and Gaspar de Portola north to Monterey in 1769. After his retirement in 1810, Yorba was granted 62,516 acres by the king of Spain, which he named Rancho Santiago de Santa Ana. (Courtesy of First American Corporation.)

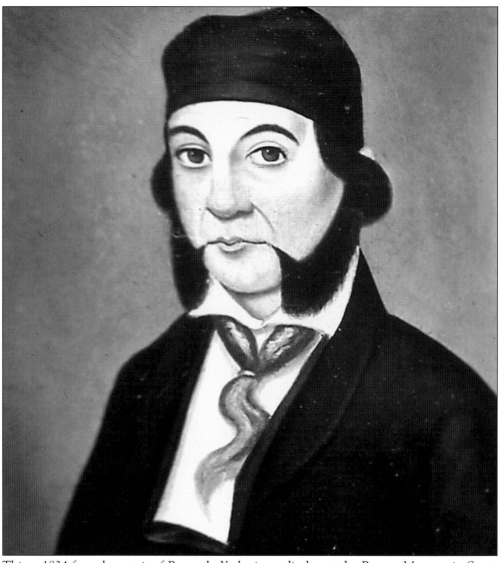

This *c.* 1834 formal portrait of Bernardo Yorba is on display at the Bowers Museum in Santa Ana. (Courtesy of Orange County Archives.)

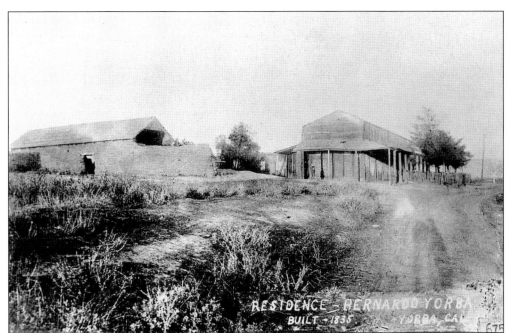

This was Bernardo Yorba's abandoned hacienda in 1924. The third son of Jose Antonio, Bernardo received a 13,328-acre grant of his own from the new Mexican government. Although Jose Antonio was the original ranchero in the area as well as the family patriarch, Bernardo's land actually covered what would become Yorba Linda. Built in 1835, his adobe was demolished in 1927. The site was designated a state historical landmark in 1950, and all that remains is a simple marker at the corner of Esperanza Road and Echo Hill Lane. (Courtesy of Orange County Archives.)

11

Here is an early rancho boundary marker. The properties themselves were unfenced. (Courtesy of First American Corporation.)

This boundary stake is from the 1800s. (Courtesy of First American Corporation.)

12

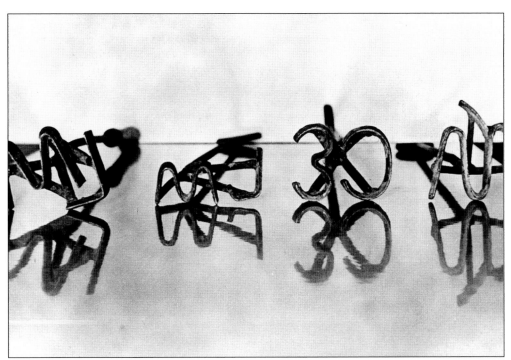

This assortment of branding irons was used to identify rancho cattle as they freely roamed the hills. (Courtesy of First American Corporation.)

RANCHERO	RANCHO	BRAND	DATE
JUAN AVILA	El Niguel		1833
MARIA YGNACIO VERDUGO	Los Verdugos		1836
JOHN ROLAND	La Puente	IR	1852
JOSÉ SEPULVEDA	San Joaquin		1839
DIEGO SEPULVEDA	Palos Verdes		1839
ABEL STEARNS	Alamitos		1839
TOMAS SANCHES	La Cienega		1842
JOHN TEMPLE	Los Cerritos		1844
BERNARDO YORBA	Santiago de Santa Ana		1844
RAMON YORBA	Santiago de Santa Ana		1844
TEODOCIO YORBA	Santiago de Santa Ana		1844
YGNACIO DEL VALLE	Camulos		1856
AUGUSTIN MACHADO	La Ballona		1844
ANDRES PICO	Ex-Mission San Fernando		1853
FRANCISCO OCAMPO	San Bartolo		1857

Ranches and their brands. El Niguel, San Joaquin, Alamitos, and Santiago de Santa Ana are located in Orange County.

This document was a key to the various rancho brands in the 1800s. Bernardo, Ramon, and Teodocio Yorba all grazed their herds on Rancho Santiago Santa Ana but branded them separately. (Courtesy of First American Corporation.)

13

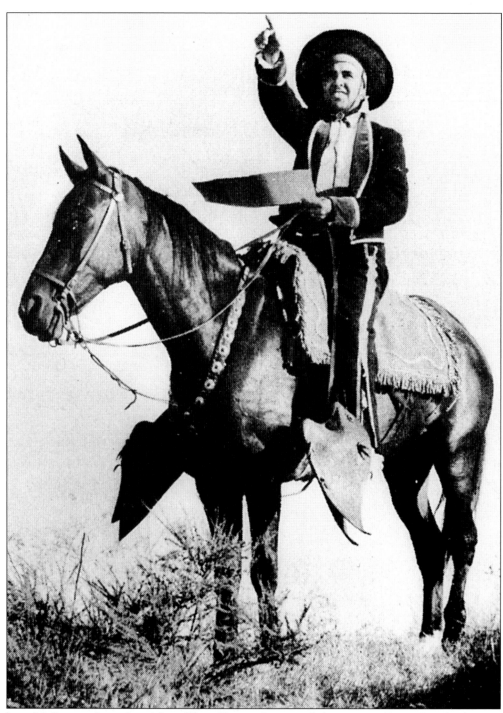

Jose del Carmen Lugo, Jose Maria Lugo, Vicente Lugo, and their cousin Diego Sepulveda were granted the nearby San Bernardino Rancho by the Mexican governor in 1852. This photograph of Jose del Carmen Lugo surveying his lands "as far as the eye can see" brings to mind how his contemporary, Bernardo Yorba, must have looked as he surveyed his own holdings. (Courtesy of First American Corporation.)

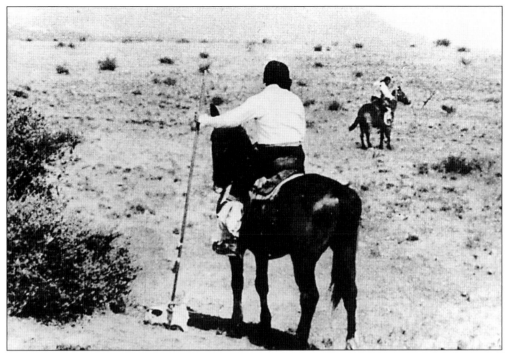

Surveyors measure and mark this unidentified rancho property in 1870. This was the era of subdivision and, subsequently, sales of rancho lands. (Courtesy of First American Corporation.)

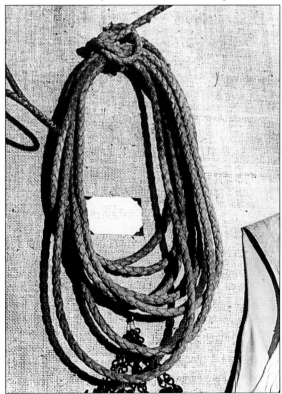

A *reata*, or braided leather rope, was used to rope cattle on the rancho. (Courtesy of First American Corporation.)

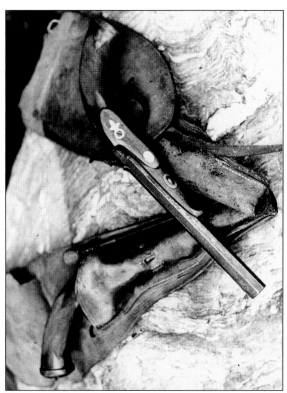

Serious matters were resolved with dueling pistols. (Courtesy of First American Corporation.)

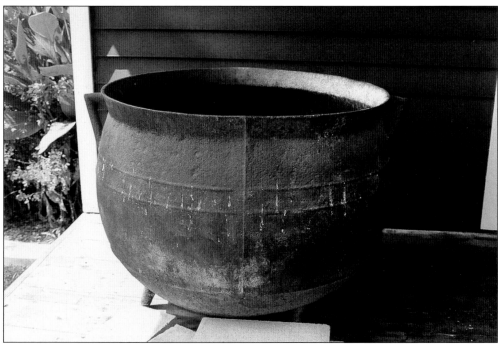

This large iron cauldron was used on Don Bernardo's rancho to boil beef fat for tallow used in soap and candlemaking. It can be seen today at the Bixby-Bryant Ranch House. (Courtesy of First American Corporation.)

These are the wedding portraits of Prudencio Yorba II, grandson of Don Bernardo, and Costancia Yorba. (Courtesy of Yorba Linda Public Library.)

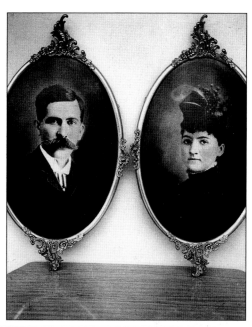

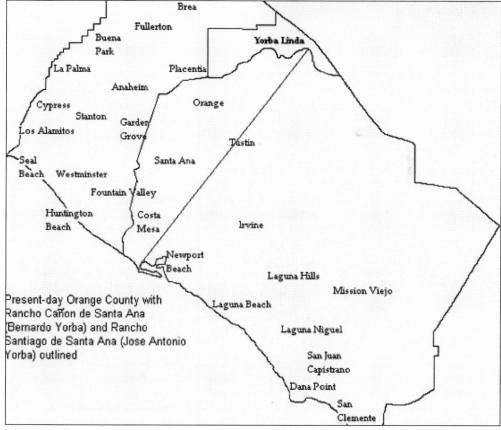

Present-day Orange County with Rancho Cañon de Santa Ana (Bernardo Yorba) and Rancho Santiago de Santa Ana (Jose Antonio Yorba) outlined

This map illustrates present-day Orange County and the location of both the Yorba ranchos. Bernardo's Rancho Canon de Santa contained Yorba Linda.

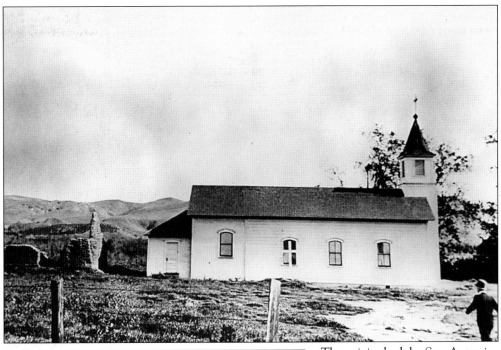

The original adobe San Antonio Chapel, built by Don Bernardo in 1859, lies in ruins on the left side of this 1935 photo. The newer wooden structure was demolished in 1956. Both were approximately located just across Esperanza Road from where the hacienda marker stands today. (Courtesy of First American Corporation.)

YORBA LINDA ORANGE LAND

The Best Proposition
In California Today

If you want to buy unimproved orange land at a rock-bottom price investigate our Yorba Linda proposition. The tract is made up of 3500 acres of the richest land in California. The soil is a deep, rich loam, underlaid by a moist sub-soil, entirely free from hard pan, alkali and adobe. The land can be worked any month of the year. The rainfall is generous and the irrigation supply is ample. Yorba Linda is in a frostless belt. Not a trace of frost has been seen during the severe weather of the present winter.

YORBA LINDA IS ON THE FAMOUS "KITE SHAPED" TRACK ON THE SANTA FE.

The fact that Yorba Linda is almost entirely surrounded by improved groves that are not for sale at any price speaks volumes for the worth of the land. The conditions that prevail in Yorba Linda are the same as in the surrounding groves—markedly superior in some instances.

Choice Ranches $250 Per Acre and Up

Terms will be arranged to suit the purchaser. Let us take you out and show you the property and let you talk with those who have made a success of ranching at Yorba Linda.

Send For Illustrated Booklet---It Is Free.

See G. H. MacGINNIS with

Janss Investment Company

LOS ANGELES 320 Pacific Electric Building SIXTH AND MAIN STREETS

This familiar Janss Company poster advertised farmland in the 1910s and can be seen reproduced in many of the businesses around town today. (Courtesy of City of Yorba Linda.)

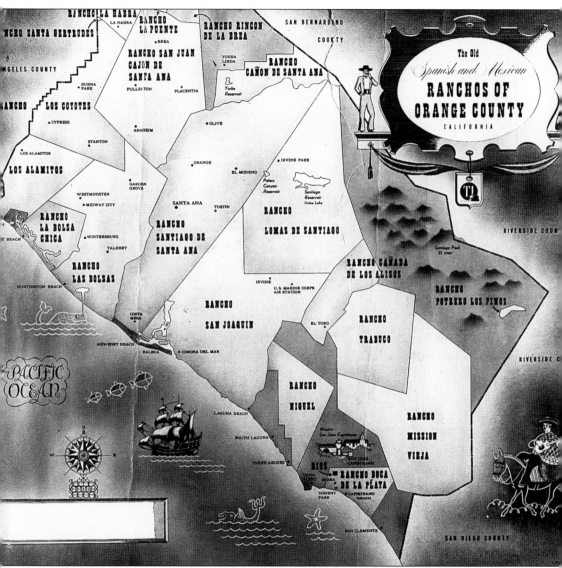

This older rancho map is on display at the First American Title Company in Santa Ana. (Courtesy of First American Corporation.)

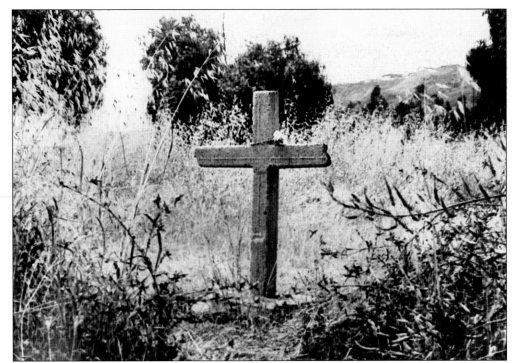

This Yorba grave is in the family cemetery located above and just to the west of the hacienda. In 1934, Angie Bleeker was the last burial at the site. The cemetery deteriorated for several decades and suffered from vandalism until it was refurbished and dedicated in 1976. It is now located in Woodgate Park, above the intersection of Esperanza Road and Fairlynn Boulevard. It is open for tours on the first Saturday of every month. (Courtesy of First American Corporation.)

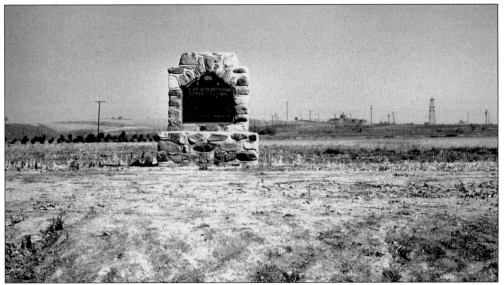

In 1961, this marker was all that remained of Bernardo's hacienda site at Esperanza Road and Echo Hill Lane. Note the wide-open space in the background. (Courtesy of Orange County Archives.)

This modern, wider shot of the same area shows the marker almost indistinguishable against a background of the landscapes and walls of a large residential development.

This would have been Bernardo's view from his home today. His beloved river can no longer be seen in an area filled with homes and industry. This train entered the frame at just the right moment.

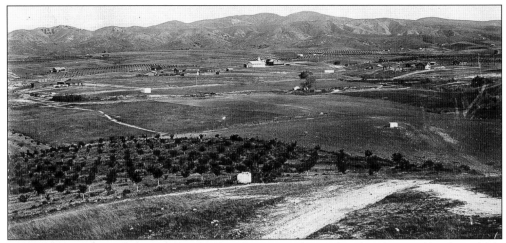

This panorama from the top of Reservoir Hill in 1914 shows the abundance of land available for farming. The only recognizable landmark is the church at the right in the distance. This was before Yorba Linda Boulevard or the landmark Packing House came into being. (Courtesy of Yorba Linda Public Library.)

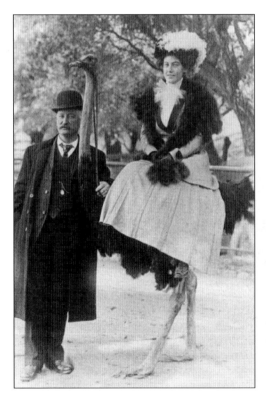

On December 25, 1910, Yorba Linda's first librarian, Gertrude Welsh, celebrated Christmas with her uncle. The bird's name was President Taft and was the main attraction at an ostrich farm in South Pasadena. Gertrude later became Mrs. Charles Selover. Some of her personal photos were donated to the Yorba Linda library and are included in this book. (Courtesy of City of Yorba Linda.)

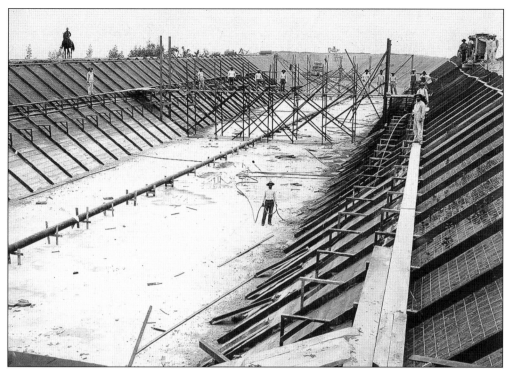

This 1910 photograph shows one of two reservoirs under construction at the time. The reservoir would be concrete-lined with a capacity of 4.5 million gallons. (Courtesy of Yorba Linda Public Library.)

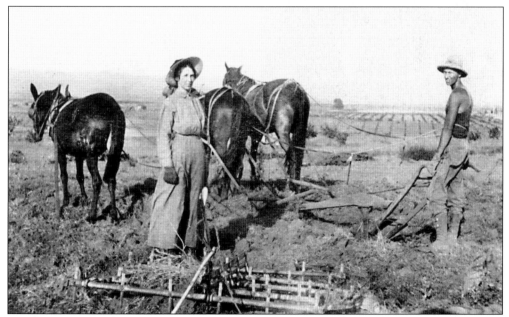

Marsha Vernon and Lee Vernon were a true pioneer couple, shown here working their land around 1912. (Courtesy of Yorba Linda Public Library.)

Cement irrigation lines are installed on the Hamburg Ranch in 1912. The teenagers are Hoyt

Corbit and Chauncy Eichler. (Courtesy of First American Corporation.)

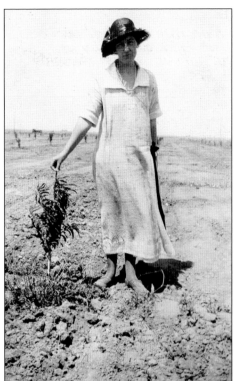

Shown here is another early field scene, identified only as the "Selover Collection." The photo was probably taken around 1920. The baby tree surely signifies a beginning for this woman and her family. (Courtesy of Yorba Linda Public Library.)

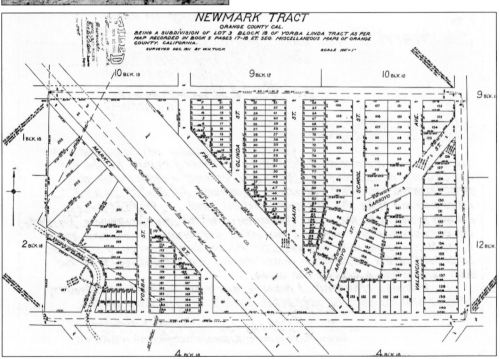

This 1912 map shows the Newmark Tract. Note the present-day Old Town in the top half. The diagonal slash of the Pacific Electric Railroad marks the future location of Yorba Linda Boulevard. (Courtesy of Orange County Archives.)

—— OWNERS CERTIFICATE ——

We hereby certify that the above map was made at our request and shows a subdivision of land owned by us, and all streets and avenues and alleys shown thereon are hereby dedicated for public use.

P. Janss & Edwin Janss —
(By) Edwin Janss
their Attorney in fact.

M. A. Newmark,
Jessie F. Newmark
By M. A. Newmark
her Attorney in fact.

Jacob Stern
Sarah Stern
By Jacob Stern
her Attorney in fact.

Herman W. Frauss
Sarah Frauss
By Herman W. Frauss
her Attorney in fact.

The
Southern Trust Co. By H. F. Stewart
Vice President
By R. Hitchins
Secretary

State of California }
County of Los Angeles } s.s.

On this 20th day of January A.D. 1912 before me Florence Ingram a Notary Public in and for the County of Los Angeles, State of California, residing therein, duly commissioned and sworn, personally appeared H. F. Stewart known to me to be the Vice-President, and R. Hitchins known to me to be the ___ Secretary of the the Southern Trust Co. the corporation that executed the within and foregoing instrument, known to me to be the persons who executed the within and foregoing instrument on behalf of the corporation named therein, and acknowledged to me that such corporation executed the same.

In Witness Whereof, I have hereunto set my hand and affixed my official seal the day and year in this Certificate first above written.

Florence Ingram
Notary Public in and for the County of Los Angeles, State of California.

Shown here are signatures from the Newmark Tract map. Note that joint ownership included the Janss' and the Sterns, who were among the earliest purchasers of Yorba family lands. (Courtesy of Orange County Archives.)

the survey represented by the ac-
companying map was made by me
June, 1914, and completed July 10, 1915

H. C. Kellogg
Licensed Surveyor

• Monument at station 82+00

• Monument at station 89+00

• Monument at station 94+29
 at top edge of hill.

Mon. station 107+53

Yorba Cottage

Grand Ave. Road

Pile Wing

North Mesa

B. Yorba House

B. Yorba Vineyard

Old Church

Yorba Ditch

S A N T

I hereby certify that the accompan-
y map represents lands owned by me
d that the survey was made at my
equest.

Samuel Kraemer

State of California,}
County of Orange, } ss

On this 22nd day of July, in the year
our Lord one thousand nine hundred and fifteen, before me,
O. W. Humphrey, a Notary Public in and for said
nty and State, residing therein, duly commissioned and sworn,
sonally appeared Samuel Kraemer, known
e to be the person described in and whose name is sub-
ribed to the annexed instrument and he acknowledged
e that he executed the same.
IN WITNESS WHEREOF, I have hereunto set my hand and affixed
official seal the day and year in this certificate first a-
e written.

O. W. Humphrey
Notary Public in and for Orange County, State of California.

SAN'A ANA Crossing Line

Iron Post with
monument 1' west.

This 1915 map of Samuel Kraemer's land includes the heart of Don Bernardo's settlement. Note the locations of the home, vineyards, church, and cemetery. (Courtesy of Yorba Linda Public Library.)

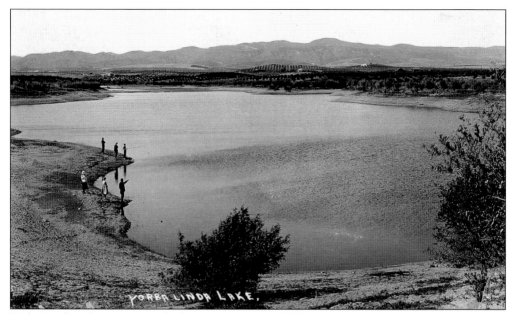

Yorba Linda Lake, a reservoir built in 1910, provided this pastoral scene in 1912. In the 1970s, the dam was condemned, the lake drained, and homes built just below it. The dam was later found to have been safe, but by then developers had already gained the upper hand. The dry lake bed itself was preserved through the efforts of the lake bed association, which planted young trees and watered them, often on horseback. (Courtesy of Yorba Linda Public Library.)

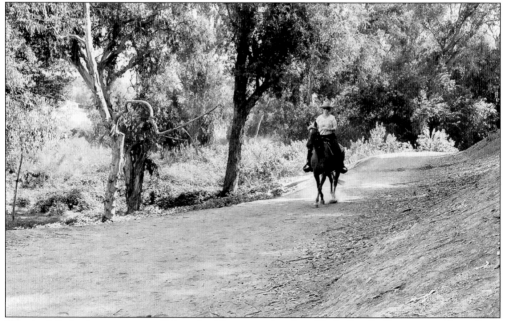

The dry lake bed remains a small bit of wilderness in bustling Yorba Linda. Equestrians, bicyclists, and walkers enjoy its wildlife and brushy scenery. It is located in the southeast quadrant of the intersection of Lakeview Avenue and Buena Vista. Natural springs bubble beneath the roots of eucalyptus and pepper trees, and hawks soar overhead. Here, Alice Munger, a lake bed association member, rides her palomino on one of the many trails.

Look carefully at the lower center of this shot to see a coyote den in the lake bed.

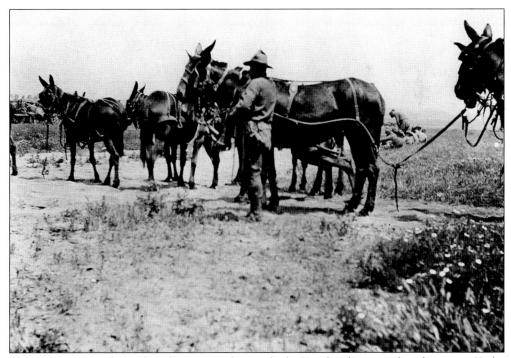

Shown here are mules and work crews used to grade the Pacific Electric right-of-way into Yorba Linda and Stern before 1911. (Courtesy of First American Corporation.)

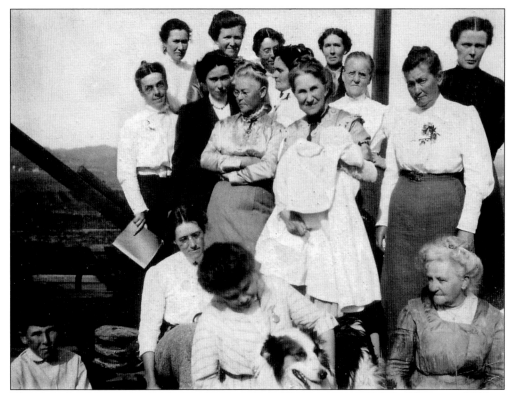

The Yorba Linda Women's Club poses here in 1913. The first president, Julia Vernon, is holding baby Richard Nixon. Hannah Nixon, his mother, is standing in the first row, second from left. (Courtesy of First American Corporation.)

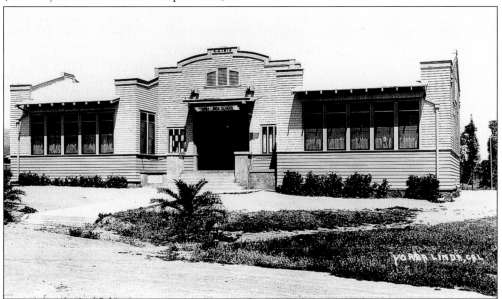

Yorba Linda's second school was located on School Street between Lemon Drive and Arroyo. It was built in 1912 to relieve overcrowding at the original schoolhouse on Olinda Street. (Courtesy of First American Corporation.)

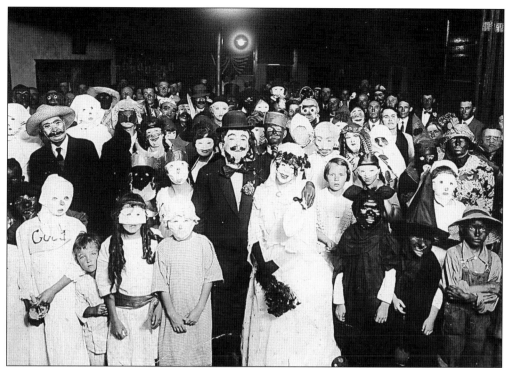

This scary Halloween party took place in the schoolhouse around 1912. (Courtesy of Yorba Linda Public Library.)

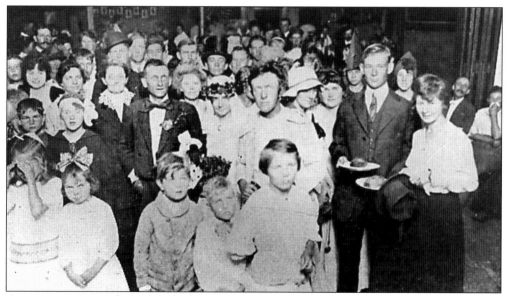

A more conventional social took place at the same schoolhouse in 1914. The couple at the far right is Chauncy Eichler and Edith Bemis. They were later married and purchased land from Frank Nixon. Edith was a schoolteacher. (Courtesy of Yorba Linda Public Library.)

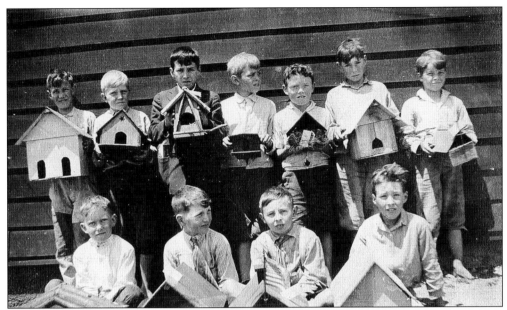

Shown here is the third- and fourth-grade Bird Club in 1916 or 1917. Pictured are (first row) Harold Nixon (Richard's brother) and Ray Walker; and (second row) Paul Ryan, Frank Marshburn, Dale Henesy, and George Gilman. (Courtesy of Yorba Linda Public Library.)

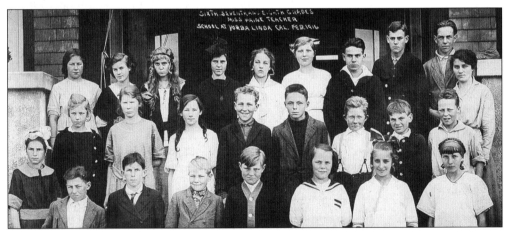

Students at Yorba Linda School, grades six, seven, and eight, are pictured here, from left to right, in 1916: (first row) Sam Gilman, Dwight Thing, Penn Marshburn, Wendell Jones, Marguerite Stewart, and Frances Shepard; (second row) Julia Buckmaster, Marion Thing, ? Stanfield, Myron West, Harrison Acker, Earling Hanson, Lester Vetter, and John Bertram; (third row) Esther Sparks, Gladys Ryan, Marjorie Hileman, Clarice Jacobs, Eva Madsen, Viola Bemis, Louis (Tad) Vetter, Paul Trook, and John Buckmaster. The teacher, Mable Paine, is on the right, between the second and third rows. (Courtesy of Yorba Linda Public Library.)

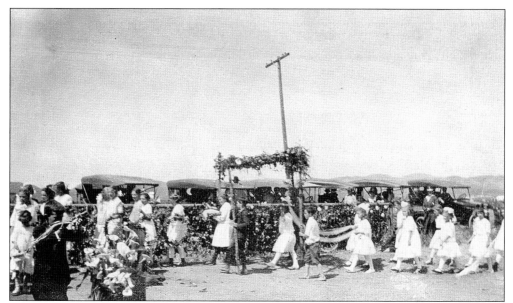

The 1917 May Day parade was indeed a glamorous affair. (Courtesy of Yorba Linda Public Library.)

Here are schoolgirls from a parade float—probably not the same parade, as these girls are not in the traditional white May Day garb. Second from the left is Winifred Selover, and fourth from the left is Lois Johnson. (Courtesy of Yorba Linda Public Library.)

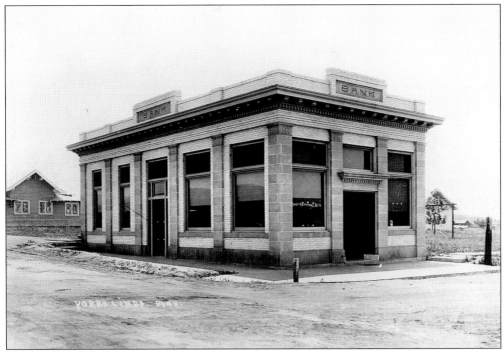

The Yorba Linda First National Bank, seen here in 1926, was located on Main Street and later became the Bank of America. (Courtesy of First American Corporation.)

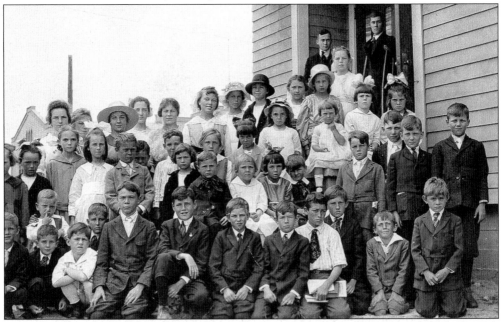

The United Presbyterian Sunday School assembles in front of the building that later became the Methodist Church. A note on the back of this undated photograph reads as follows: "Helen is just in front of the boy with crutches and Murray in front of her. Anna Lufton the little one near the center in a black coat. Watson Lufton . . . the bottom row on the right and Benjamin the 5th boy." (Courtesy of Yorba Linda Public Library.)

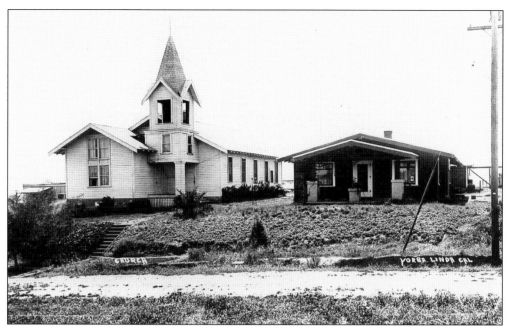

The Yorba Linda Friends Church was built in 1912 at a cost of $1,513.63. It was the first church in Yorba Linda and still stands on School Street between Lemon Drive and Arroyo. Among its pioneer members were Frank and Hannah Nixon, parents of Richard M. Nixon. This photo was taken in 1927. (Courtesy of First American Corporation.)

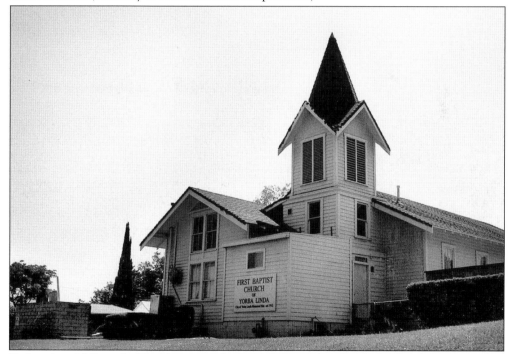

Today, the old Friends Church is now the First Baptist Church. Physically, the structure has changed very little. The main differences are an extension and enclosure of the front porch, and louvers added to the bell tower.

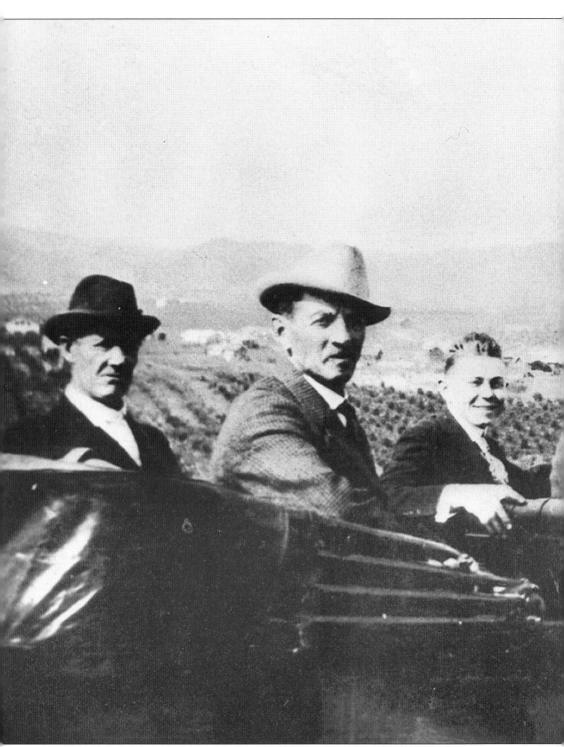

This photo, taken from Reservoir Hill after 1920, shows the Packing House (center right) that was destroyed in a 1929 fire and rebuilt in concrete the following year. It is still located at 18200 Yorba Linda Boulevard and has been refurbished as a health club and office building.

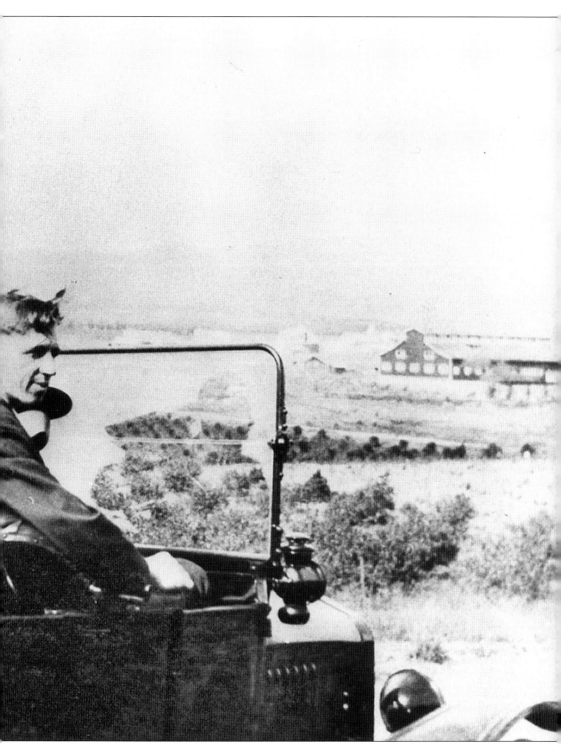

Hoyt Corbit is on the right in the front seat. His parents, George and Mildred Corbit, were among the first farm families in the area and only the second to purchase land from the Janss Company. (Courtesy of First American Corporation.)

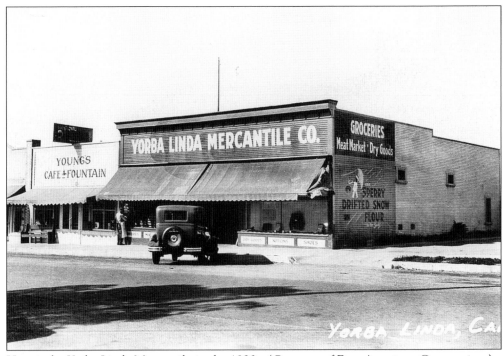

Here is the Yorba Linda Mercantile in the 1920s. (Courtesy of First American Corporation.)

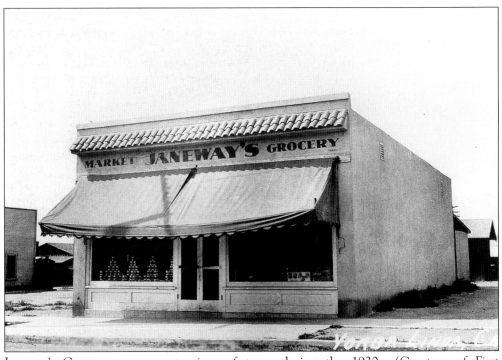

Janeway's Grocery was a centerpiece of town during the 1920s. (Courtesy of First American Corporation.)

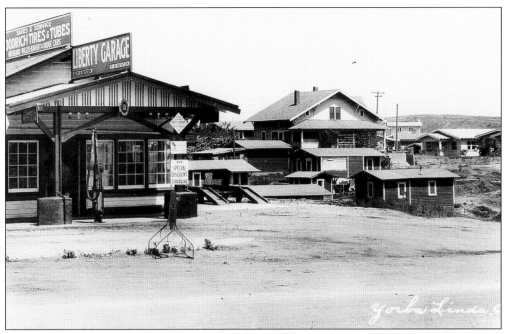

The Liberty Garage downtown was built and owned by Hurless Barton, son of John Barton, a builder who moved to Yorba Linda in 1912. This photo was probably taken in the 1930s. (Courtesy of First American Corporation.)

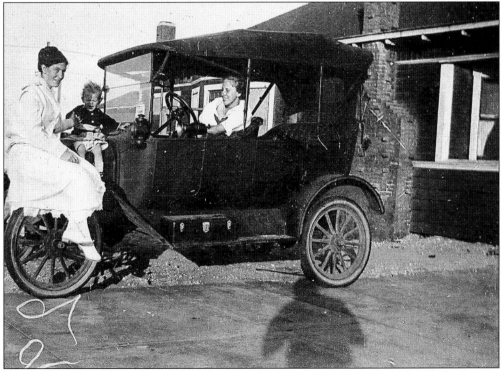

Are they posing with their new car? This c. 1925 photo is from a group marked "Charles Selover Collection." (Courtesy of Yorba Linda Public Library.)

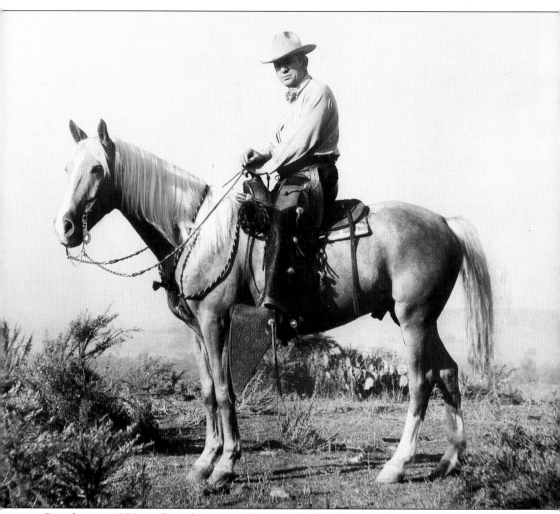

Seen here in 1930 is a formal portrait of Vicente Yorba, the son of Bernardo, on horseback. His second wife, of 22 years, was Felipa. This photo certainly invokes the days of Don Bernardo, the grand ranchero, as he surveyed his lands. (Courtesy of Yorba Linda Public Library.)

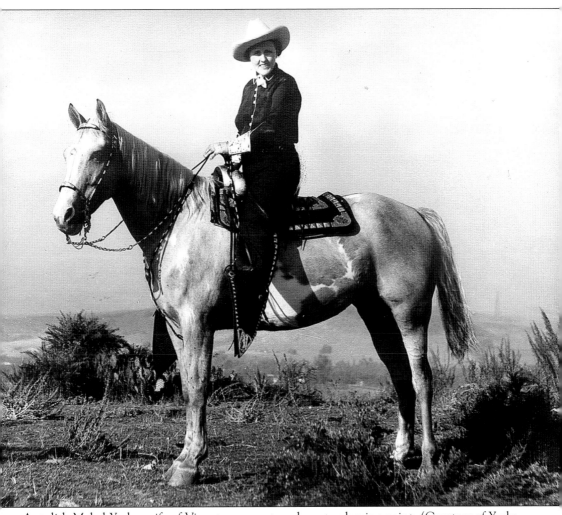

A stylish Mabel Yorba, wife of Vicente, poses atop elegant palomino paint. (Courtesy of Yorba Linda Public Library.)

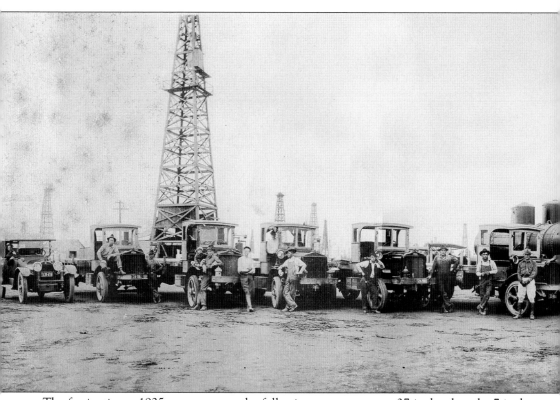

The fascinating c. 1925 panorama on the following pages measures 37 inches long by 7 inches high. The original print belongs to Yorba Linda native Jim Tice, whose grandfather was a teamster in the oilfields. Jim's maternal grandparents, Herbert Anderson and Mary Quirk, purchased land while on their honeymoon in 1916. Herbert traded farming implements, horses, and harnesses for the small farm he used for avocados. Note the wooden derricks in the background.

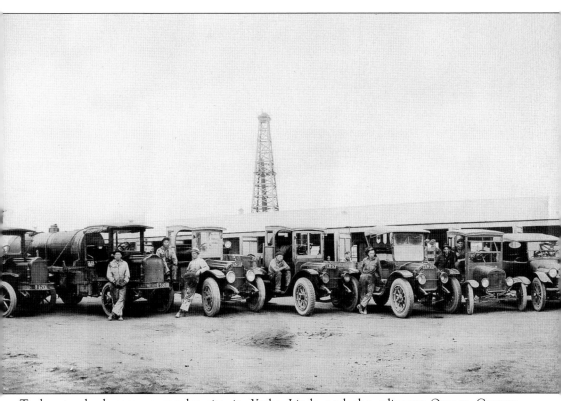

Tanker trucks became a regular site in Yorba Linda and the adjacent Orange County communities after petroleum started becoming a big business.

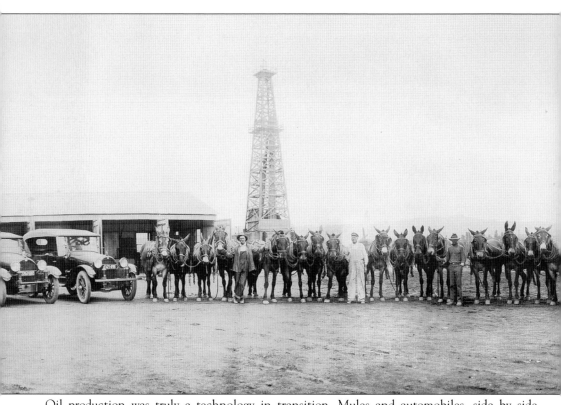

Oil production was truly a technology in transition. Mules and automobiles, side by side, supplied transport and labor needs to the "black gold" industry. The oilfields in Yorba Linda were the first to successfully use the steam-extraction method.

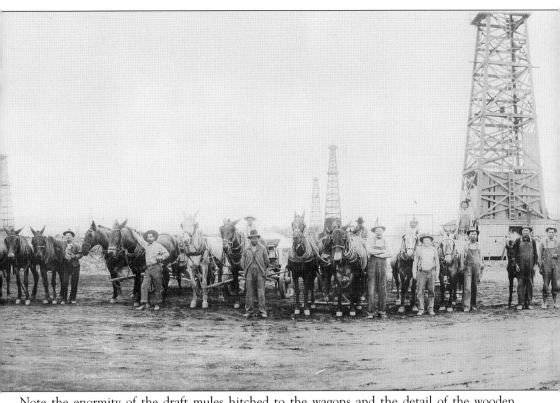

Note the enormity of the draft mules hitched to the wagons and the detail of the wooden derrick at the far right.

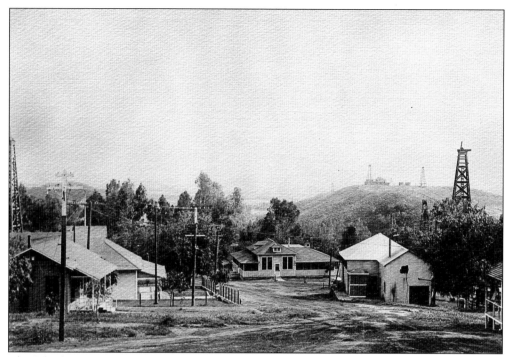

The Olinda Land Company oil field was the major non-agricultural employer in Yorba Linda in the mid-1920s. (Courtesy of Yorba Linda Public Library.)

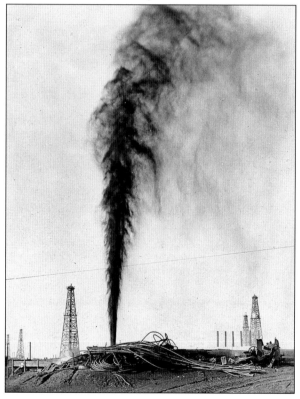

This 1920s photograph shows oil gushing from a strike on the day after it came in. (Courtesy of Yorba Linda Public Library.)

Here is a night scene of an oil-well blowout on the Thompson lease on Jefferson Street in 1920. (Courtesy of Yorba Linda Public Library.)

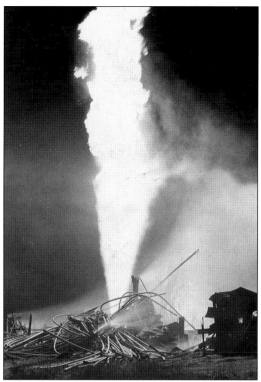

Dedication of the second Friends Church building took place in 1928. It was located at 4842 Main Street. (Courtesy of Friends Church.)

Here is an early view of the same Friends Church. It still stands at 18372 Lemon Drive in Old Town and is now the First Baptist Church of Yorba Linda. (Courtesy of Yorba Linda Public Library.)

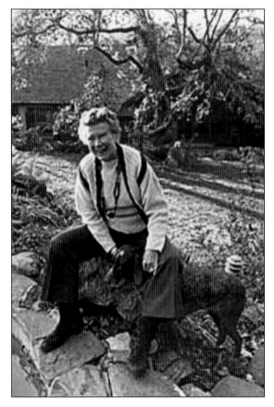

Jessamyn West (1903–1984), local friend and famous author, wrote several books, including *Friendly Persuasion*, which was made into a 1956 movie starring Gary Cooper and Dorothy McGuire. The film, directed by William Wyler, was nominated for six Academy Awards. She is seen here in 1974. (Courtesy of Yorba Linda Heritage Society.)

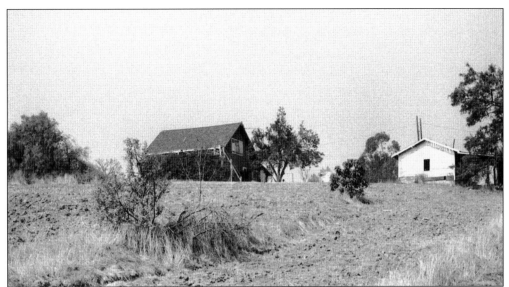

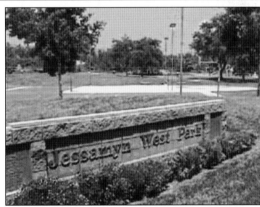

Pictured above is the home of Eldo West, Jessamyn's father. He was superintendent of the Yorba Linda Water Company. Today, Jessamyn West Park (right) marks the site where the home once stood. (Courtesy of Phil Brigandi.)

Eldo West arrived in Yorba Linda during the farming boom in 1910 and planted lemons. He built this home, seen here in 1980, in 1911. The house—then the oldest surviving home in Yorba Linda—was nominated for the National Register of Historic Places in 1981 but was destroyed in an arson fire in 1982 before the official process was complete. The home was located at Yorba Linda Boulevard and Palm Avenue, now the site of Jessamyn West Park. (Courtesy of Phil Brigandi.)

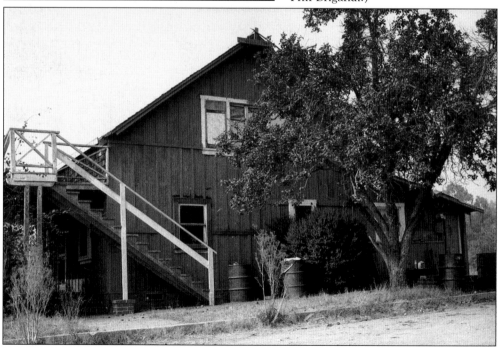

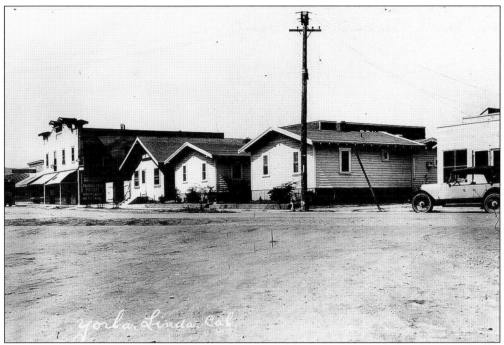

This scene is of downtown Main Street as it looked in the 1920s. The familiar facade of the Hardware Store can be seen on the far left. (Courtesy of First American Corporation.)

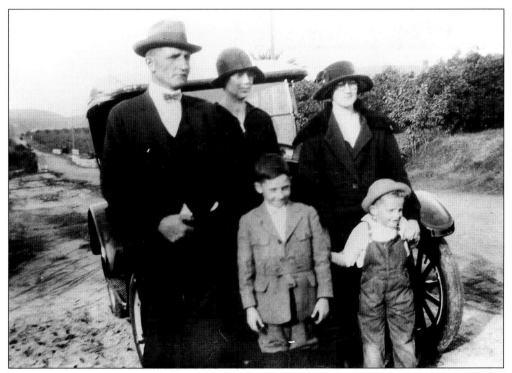

Traveling up Lakeview Avenue in December of 1925, the Cromwells enjoyed a lovely Sunday drive. (Courtesy of First American Corporation.)

The Nay family pauses for a photo in 1931 on Palm Avenue, then the main road from Yorba Linda to Fullerton. (Courtesy of First American Corporation.)

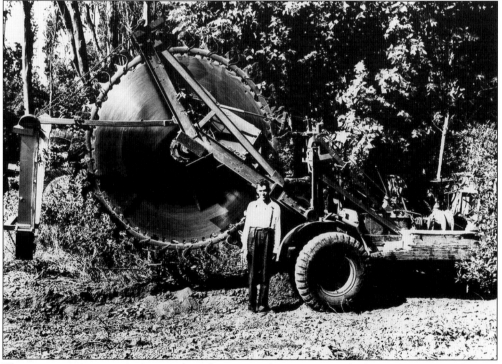

This gigantic pruning saw was used on the W. H. Thompson Ranch, located at 5712 Lakeview Avenue, in 1949. (Courtesy of First American Corporation.)

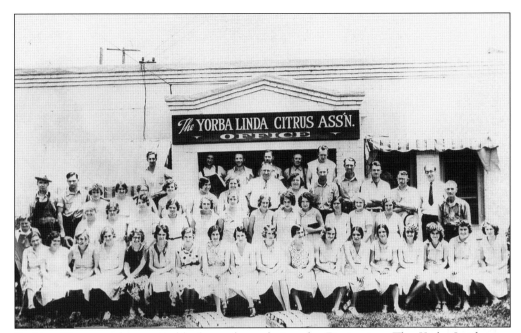

Packing House workers assemble for a photo during the Depression. The Yorba Linda area was not heavily impacted by the Great Depression due to its self-sufficiency as an agricultural community. However, it became difficult for farmers to pay laborers with the subsequent drop in produce prices. (Courtesy of First American Corporation.)

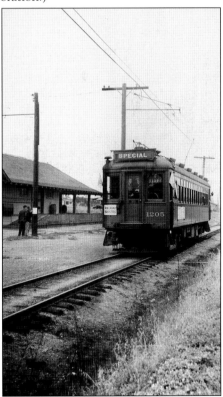

Seen here in 1939 is the Yorba Linda Railroad Station that was built in 1912. The station is now Polly's Pies, and contains many historic photos of the city. The final leg of the Pacific Electric Red Car Line went through Fullerton and ended in Yorba Linda, crossing the Nixon property. Most Red Car service ended by the 1950s, when the right-of-way yielded to auto traffic. On May 14, 1939, the Railroad Boosters of Los Angeles chartered Pacific Electric Car No. 1205 for a day's outing in the country, traveling to Yorba Linda at the end of the line. Likewise, Yorba Linda residents would often take the earliest car into Los Angeles and return on the latest. (Courtesy of Yorba Linda Public Library.)

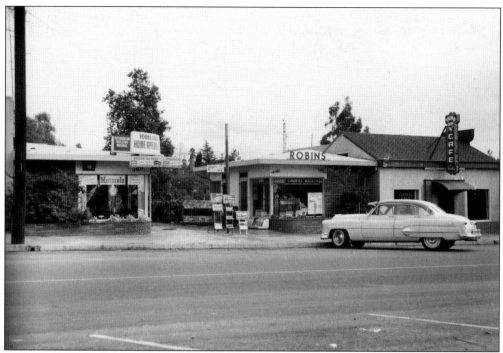

On December 1, 1952, Yorba Linda Boulevard businesses included an appliance store, Robin's Market, and Turner's Cafe and Fountain. (Courtesy of Chris Jepsen collection.)

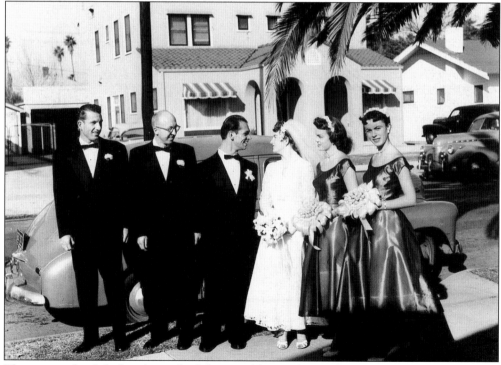

This crisp and stylish shot shows the Schivo wedding on November 13, 1954. (Courtesy of First American Corporation.)

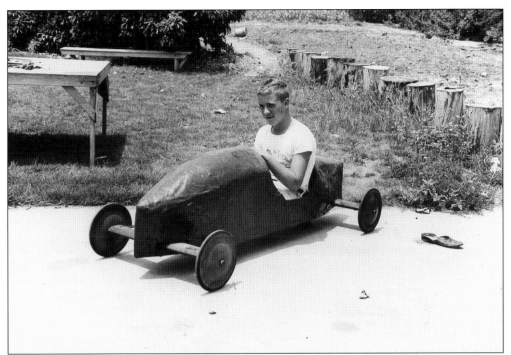

In 1953, Woody Simart appears absolutely ready for the soapbox derby. (Courtesy of First American Corporation.)

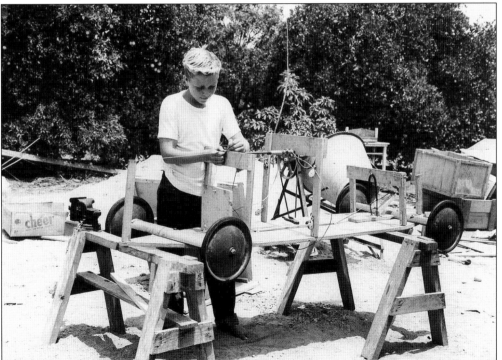

Richard Hyatt, also seen in 1953, readies his own soapbox racer. (Courtesy of First American Corporation.)

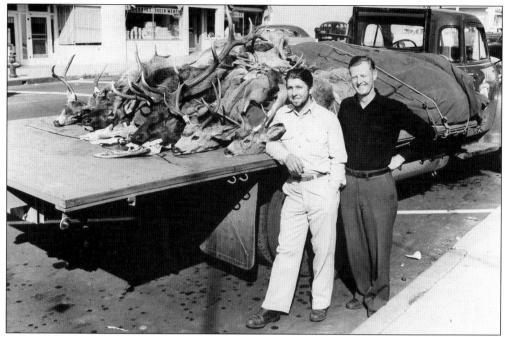

On November 8, 1951, Boyd Smoot, of 6241 Park Avenue, returns from a successful hunt. Where he went is anyone's guess, but a close look at his take reveals that he "bagged" deer, an elk, and javelina (wild pigs). (Courtesy of First American Corporation.)

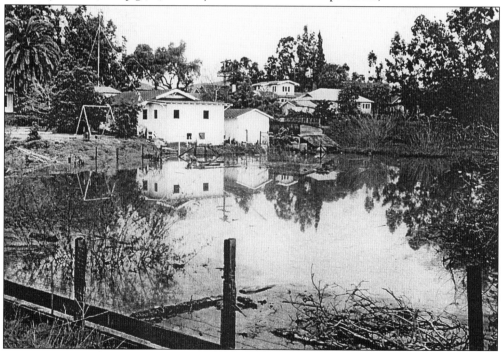

The rear of the Alex T. Sim home at 4922 Shaw Lane is depicted here during the 1952 flood. The entire Santa Ana Canyon area was flooded when the river rose after heavy rains. (Courtesy of First American Corporation.)

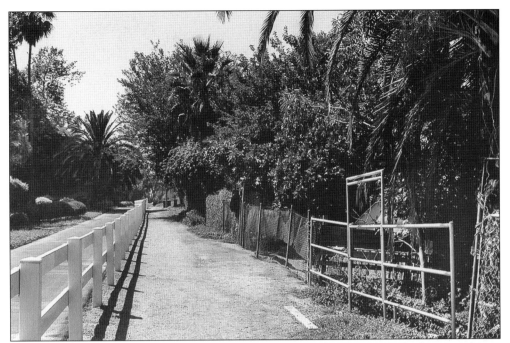

Today, the rear of the Sim house is obscured by structures and foliage, but the horse trail next to it is high and dry. The gully itself is now filled with horse corrals. The same white house can be seen through the pipe fence at the right.

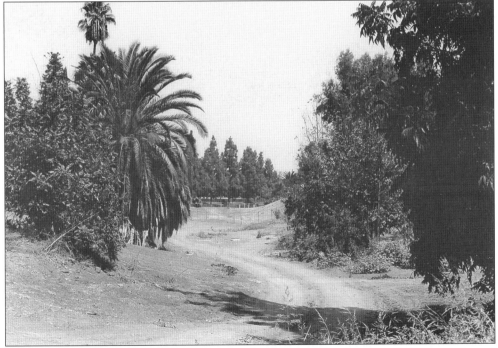

This shot of the gully area is just slightly south of the old Sim house and shows vestiges of Yorba Linda's quickly disappearing rural past. It is just north of Yorba Linda Boulevard and Eureka Avenue.

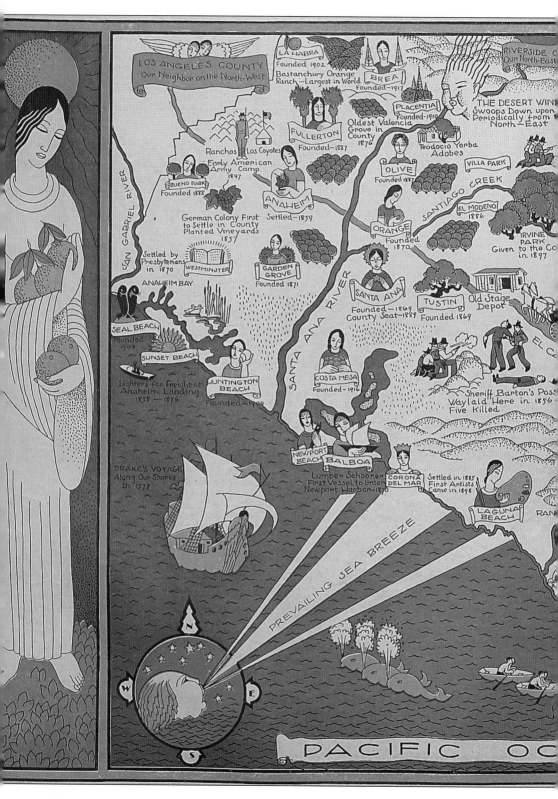

LOS ANGELES COUNTY
Our Neighbor on the North-West

RIVERSIDE C
Our North-East

LA HABRA
Founded 1902
Bastanchury Orange
Ranch—Largest in World

BREA
Founded—1917

PLACENTIA
Founded—1910

THE DESERT WIN
Swoops Down upon
Periodically from
North-East

Oldest Valencia
Grove in
County
1876

Teodocio Yorba
Adobes

FULLERTON
Founded—1887

VILLA PARK

Ranchos Los Coyotes
Early American
Army Camp
1847

OLIVE
Founded 1887

BUENO PARK
Founded 1888

ANAHEIM
Settled—1859

SANTIAGO CREEK

EL MODENO
1886

ORANGE
Founded
1870

IRVINE
PARK
Given to the Co
in 1897

German Colony First
to Settle in County
Planted Vineyards
1857

Settled by
Presbyterians
in 1870

WESTMINSTER

GARDEN
GROVE
Founded 1871

ANAHEIM BAY

SANTA ANA
Founded—1869
County Seat—1889

TUSTIN
Founded 1869

Old Stage
Depot

SEAL BEACH
Founded
1904

SUNSET BEACH

EL C

Lighters for Freight of
Anaheim Landing
1858 — 1876

HUNTINGTON
BEACH
Founded—1904

COSTA MESA
Founded—1916

Sheriff Barton's Pos
Waylaid Here in 1856-
Five Killed

DRAKE'S VOYAGE
Along Our Shores
In 1579

NEWPORT
BEACH
BALBOA

CORONA
DEL MAR

Settled in 1885
First Artists
Came in 1898

Lumber Schooner
First Vessel to Enter
Newport Harbor—1870

LAGUNA
BEACH

RAN

PREVAILING SEA BREEZE

N
W E
S

PACIFIC OC

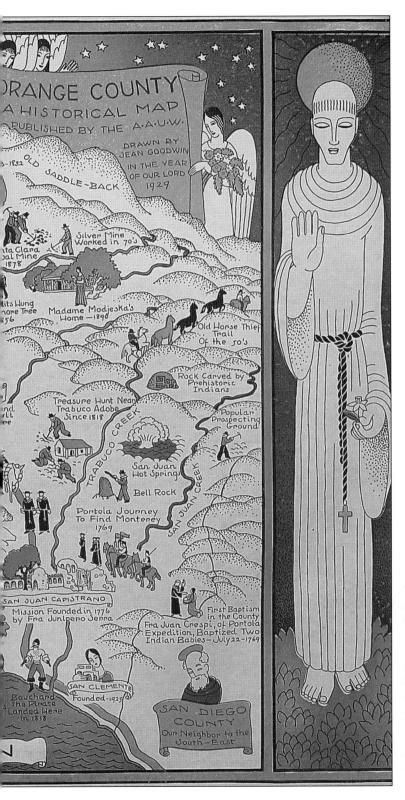

This 1929 souvenir map drawn by Jean Goodwin Ames shows places, people, and local lore. It was in color, and original prints are on display at the Orange County Archives and the Bixby-Bryant Ranch. (Courtesy of Orange County Archives.)

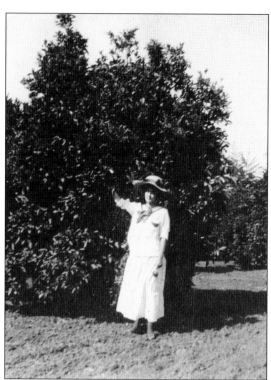

Here is another unmarked photo from Mr. Selover. The woman's outfit and the maturity of this orange tree suggest it was taken in the late 1920s. (Courtesy of Yorba Linda Public Library.)

Family or friends of Mr. Selover gather for this shot in 1939. (Courtesy of Yorba Linda Public Library.)

Two

FAVORITE SON
RICHARD MILHOUS NIXON

Young Richard Nixon is seen here on the north side of the Frank Nixon home in 1914. The Packing House can be seen on the right. (Courtesy of Richard Nixon Library.)

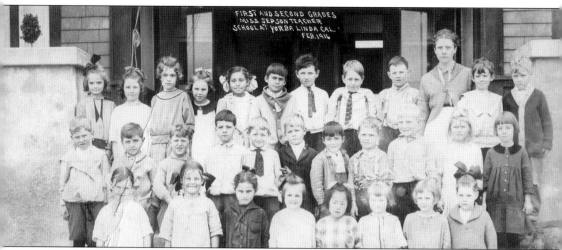

Harold Nixon's first-grade class is depicted here in February 1916. Harold was one of Richard Nixon's brothers. (Courtesy of Richard Nixon Library.)

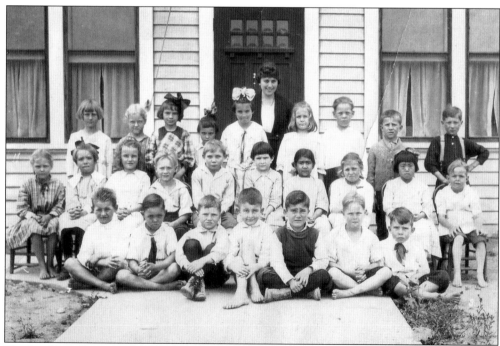

Teacher Mary Skidmore's first-grade class in 1919 included Richard Nixon (first row, far right). (Courtesy of Richard Nixon Library.)

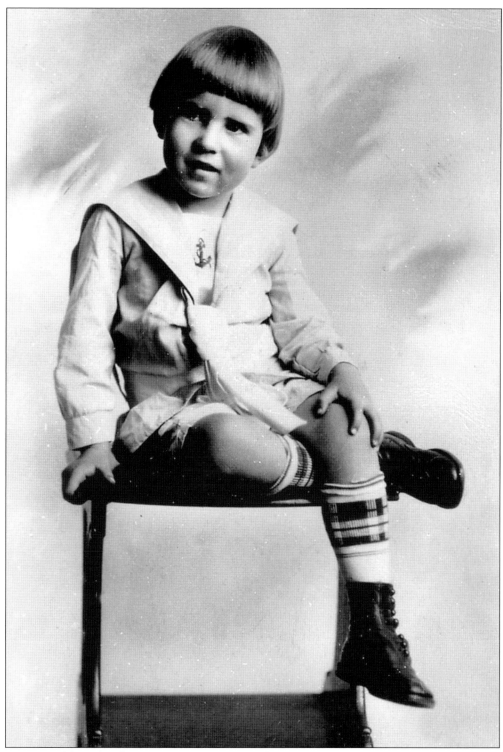

Five-year-old Richard Nixon sits for a formal portrait in 1918. (Courtesy of Richard Nixon Library.)

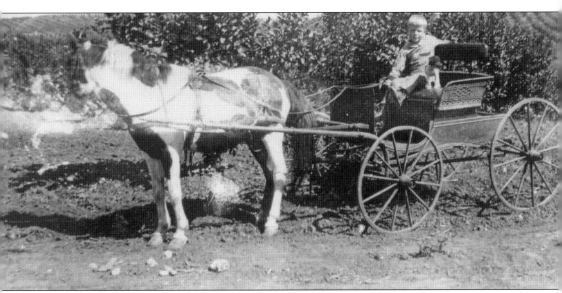

Maxwell Williams, childhood friend of the future vice president under Dwight Eisenhower, poses in a pony cart in 1918. (Courtesy of Richard Nixon Library.)

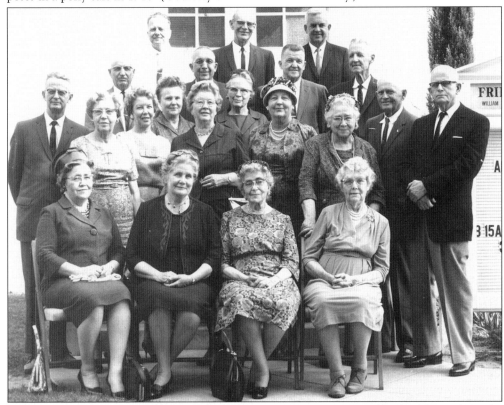

The Friends Church's 50th anniversary in 1962 was a festive occasion. This building, where the Nixons were regular worshipers, was later used as a social hall. Member Charlie Rogers fondly recalls the annual picnic and steak fry and that he "cut into many a steak there." (Courtesy of Yorba Linda Public Library.)

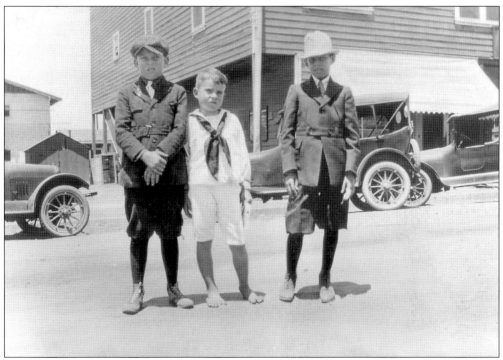

Harold Nixon (left), Richard Nixon (center), and Floyd Wildermuth are shown on Main Street in 1920. (Courtesy of Richard Nixon Library.)

Frank Nixon's Sunday-school class is shown in 1920. Mr. Nixon, Richard's father, is on the far right. (Courtesy of Richard Nixon Library.)

The Nixon brothers are shown at play in the yard in 1922. Pictured, from left to right, are Richard, Harold, Francis, and Arthur. Arthur would die three years later, at the age of seven, from tubercular encephalitis. In 1923, the family moved to Whittier, where a fifth brother, Edward, was born in 1930. Richard would eventually attend Whittier High School and graduate from Whittier College in 1934. (Courtesy of Richard Nixon Library.)

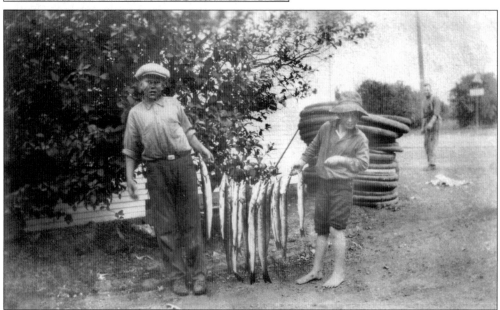

Frank Nixon opened a store and gas station in Whittier in 1923. Harold Nixon (left) and George Burnett are shown on the east side of the gas station looking north. (Courtesy of Richard Nixon Library.)

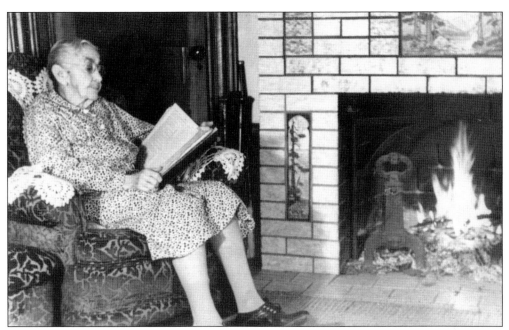

Hannah Almira Milhous, Nixon's mother, is seen here in her Whittier home. She died at the age of 94 on July 23, 1943. (Courtesy of City of Yorba Linda.)

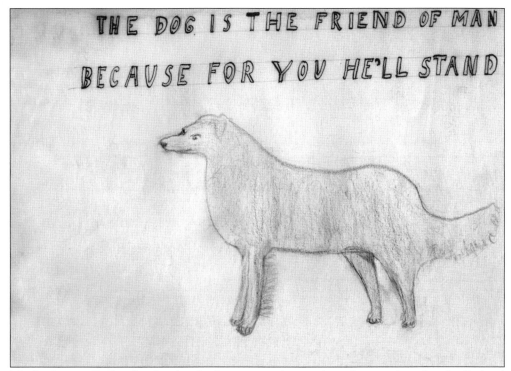

THE DOG IS THE FRIEND OF MAN

BECAUSE FOR YOU HE'LL STAND

Much of young Richard's schoolwork, drawings, and essays have been archived at the Richard Nixon Presidential Library and Birthplace. This drawing of a dog and its caption by the future president are particularly charming. (Courtesy of Richard Nixon Library and Birthplace.)

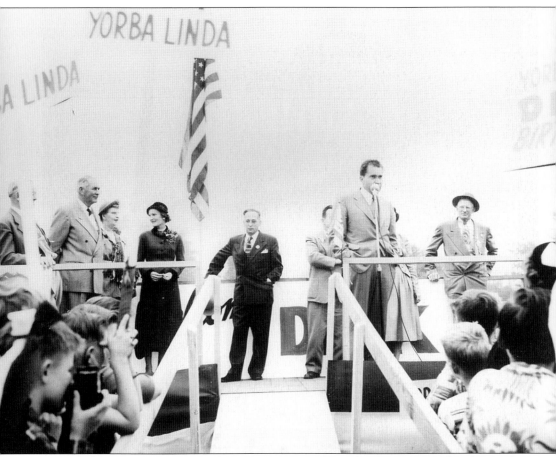

Richard Nixon held a vice-presidential campaign rally in his hometown of Yorba Linda on October 30, 1952. (Courtesy of First American Corporation.)

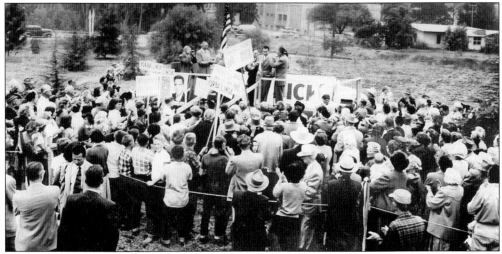

Yorba Linda's biggest business, the Packing House, appears in the immediate background of this campaign rally photo. (Courtesy of First American Corporation.)

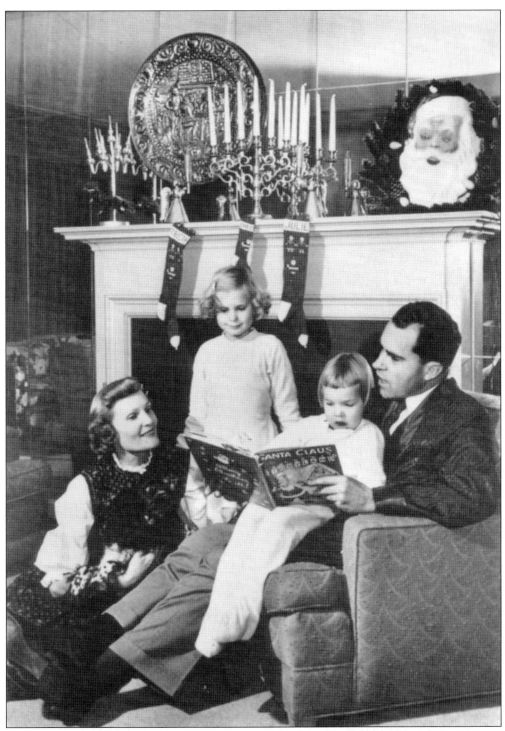

Richard Nixon reads to his young family in 1953. The vice president and his wife Pat are seen with their daughters Tricia and Julie, seven and five years old respectively. (Courtesy of Richard Nixon Library.)

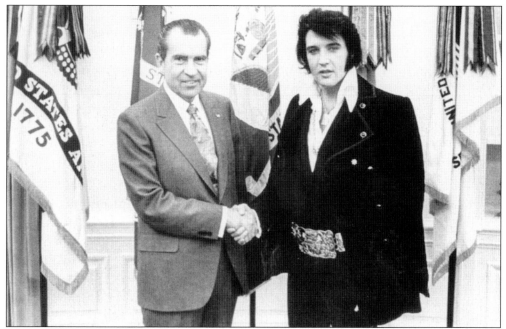

President Nixon and "The King" meet at the White House in 1970. Elvis presented the president with a chrome World War II Colt .45 pistol and silver bullets from his own collection. These are on display at the Richard Nixon Library. (Courtesy of Richard Nixon Library.)

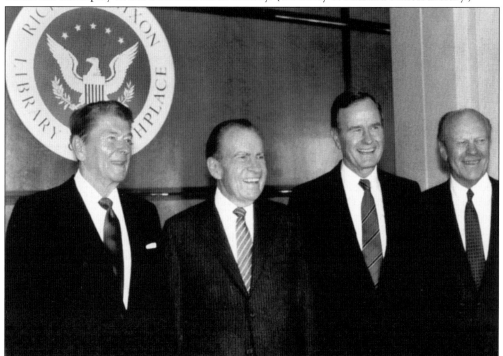

The Richard Nixon Library and Birthplace was dedicated on July 19, 1990. Presidents Ronald Reagan, Richard Nixon, George Bush, and Gerald R. Ford posed for pictures in the lobby before touring the library. (Courtesy of Richard Nixon Library.)

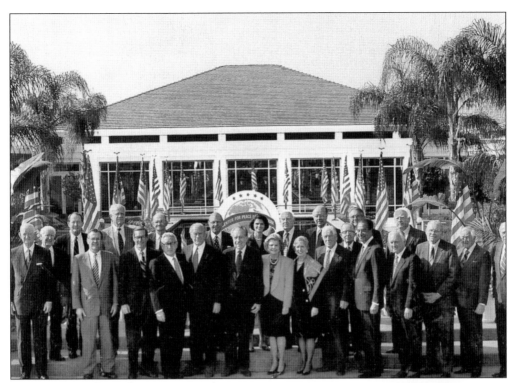

A gala event—the 25th anniversary of Richard Nixon's first inauguration—took place at the library on January 20, 1994. Pictured, from left to right, are the following: (first row) Postmaster Blount, Defense Sec. Rumsfeld, Treasury Sec. Simon, Sec. of State Kissinger, President Ford, President Nixon, Betty Ford, Commerce Sec. Franklin, HUD Sec. Romney, HUD Sec. Pierce, Interior Sec. Hickel, HEW Sec. Finch, Commerce Sec. Stans, and Treasury Sec. Shultz; (second row) Education Sec. Bell, Education Sec. Alexander, Defense Sec. Schlesinger, Transportation Sec. Brinegar, Labor Sec. Hodgson, Labor Sec. McLaughlin, Sec. of State Rogers, OMB Dir. Ash, Economic Advisor McCracken, Commerce Sec. Peterson, and Labor Sec. Brennan. (Courtesy of Richard Nixon Library.)

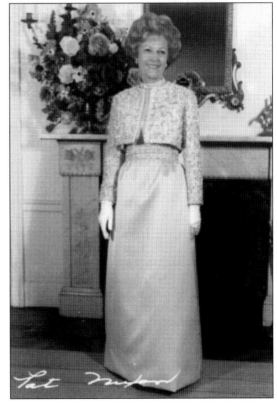

Pat Nixon models her gown for the 1969 inaugural ball. Several of her gowns are displayed at the Richard Nixon Library. (Courtesy of Richard Nixon Library.)

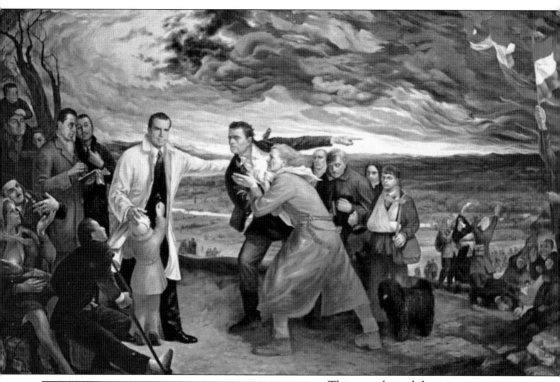

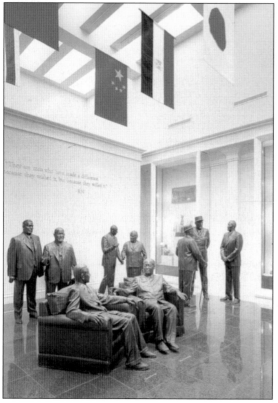

This mural-sized, heroic scene was painted by Hungarian-American artist Ferenc Daday. It commemorates then vice president Nixon's visit to the village of Andau in 1956 after the Soviets crushed an anti-communist revolution in Hungary. Stormy grays and blood-red tones dominate a scene that is both pathetic and hopeful as Nixon receives the battered refugees. (Courtesy of Richard Nixon Library.)

Life-sized statues depict world leaders who were respected by President Nixon. Guests may walk freely into the display, which includes gifts of state presented to the Nixons. (Courtesy of Richard Nixon Library.)

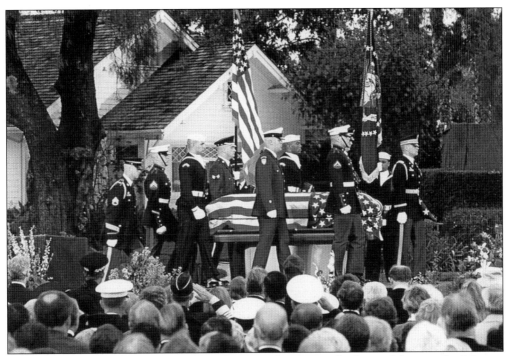

Here, a military honor guard escorts the flag-draped casket to the front of the president's home and birthplace. He was buried next to the First Lady, Pat, on the premises. (Courtesy of Richard Nixon Library.)

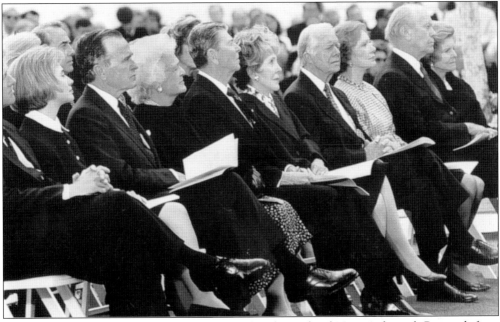

Former presidents and their wives gather together for Richard Nixon's funeral. Pictured, from left to right, are Bill and Hillary Rodham Clinton, George and Barbara Bush, Ronald and Nancy Reagan, Jimmy and Rosalynn Carter, and Gerald and Betty Ford. (Courtesy of Richard Nixon Library.)

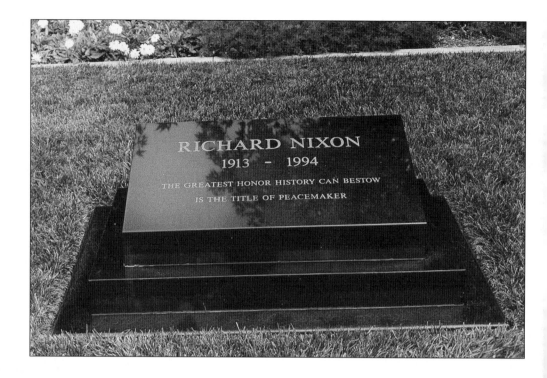

The gravesites of Richard and Pat Nixon are on the birthplace premises, side by side, on a grassy plot surrounded by roses.

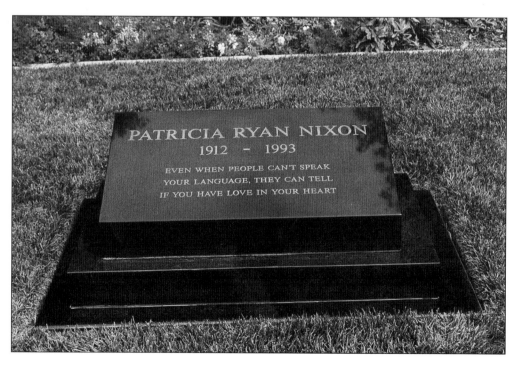

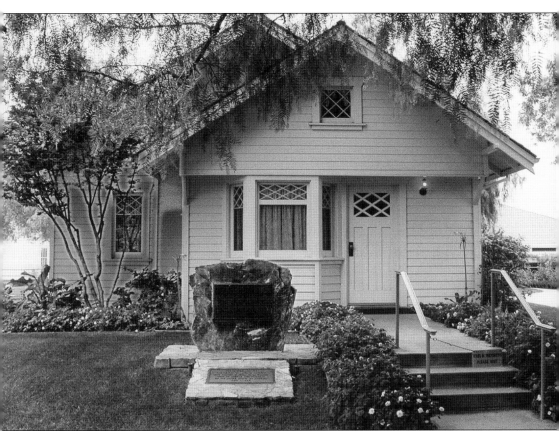

The front of Richard Nixon's birthplace faces diagonally toward Yorba Linda Boulevard and away from the museum. The former president insisted that it remain in its original orientation. Daily tours of the small house are available.

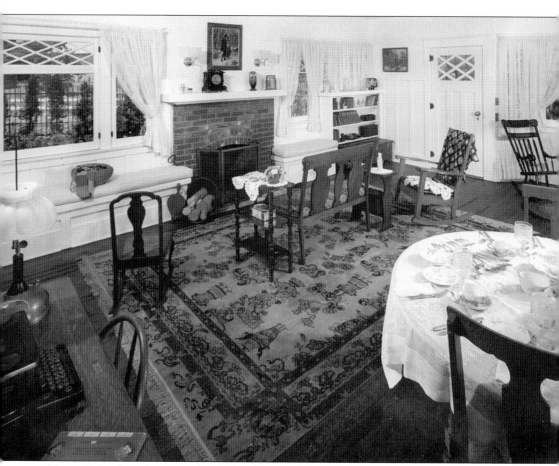

Many of the furnishings in the Richard Nixon birthplace are original and include the piano upon which young Richard practiced. (Courtesy of Richard Nixon Library.)

Three

LAND OF
GRACIOUS LIVING

The Nixon School PTA is shown in 1953. The school was originally located at the Richard Nixon Library site. Mr. Edwards (first row, third from the right) went on to become the principal. (Courtesy of First American Corporation.)

Curtis W. Morris, president of the Yorba Linda Water Company, served on its board for 32 years. This picture was taken on January 20, 1950. He resided at 18402 Yorba Linda Boulevard. (Courtesy of First American Corporation.)

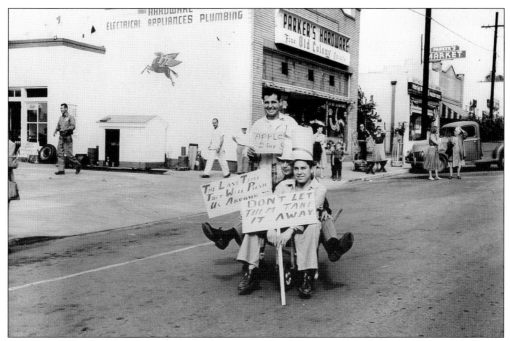

On November 5, 1952, an election "dare" was paid off in front of Parker's Hardware. Whatever the dare and payoff were have been lost to history. Pictured, from left to right, are Robert Parker, Mr. Lucas, and Mr. Alexander." (Courtesy of First American Corporation.)

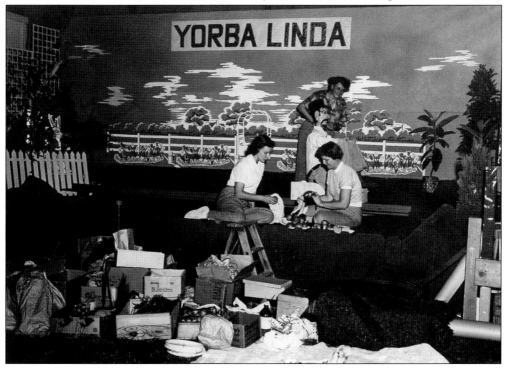

Volunteers assemble Yorba Linda's city display at the 1953 Orange County Fair. (Courtesy of First American Corporation.)

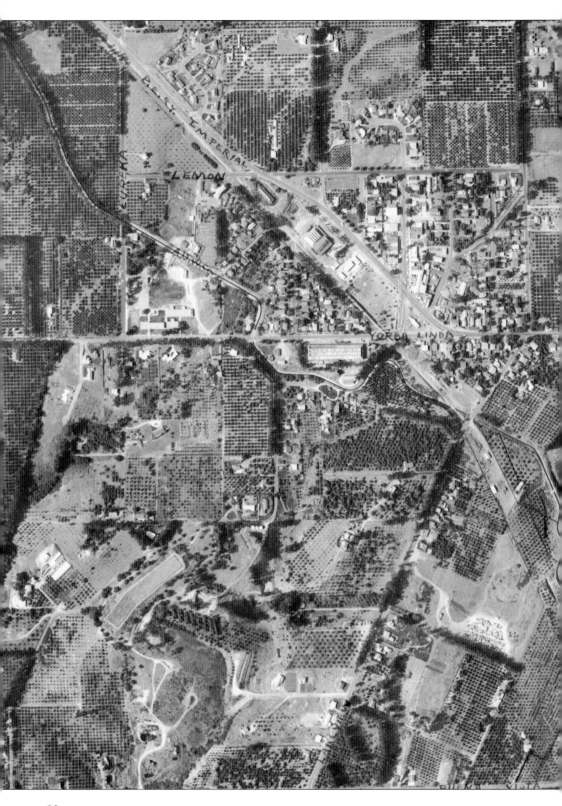

This aerial photo shows Yorba Linda in 1955. Note the familiar triangle formed by Lakeview Avenue, Imperial Highway, and Yorba Linda Boulevard. This view recurs in many maps and other diagrams of the area. (Courtesy of Orange County Archives.)

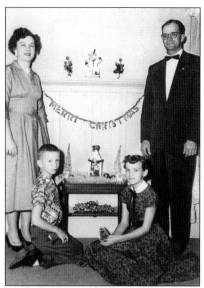

The Steffers family poses for a 1954 Christmas portrait. (Courtesy of First American Corporation.)

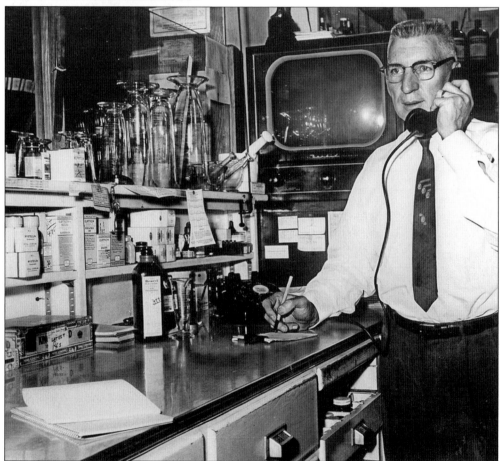

On March 3, 1957, Burt Brooks was photographed conducting business at the Yorba Linda Drugstore at 4895 Main Street. (Courtesy of First American Corporation.)

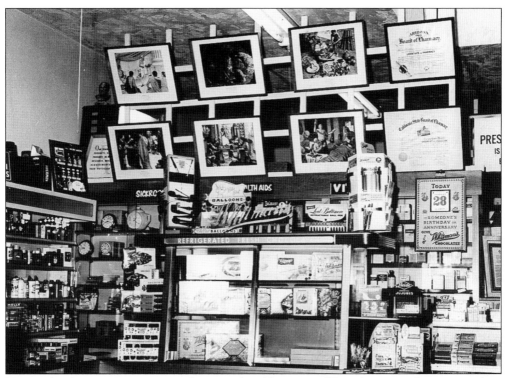

Here is the drugstore's interior on the same day. (Courtesy of First American Corporation.)

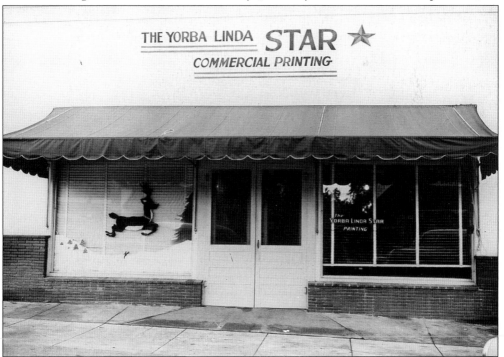

In 1950, the *Yorba Linda Star* operated out of this storefront at 4900 Main Street. (Courtesy of First American Corporation.)

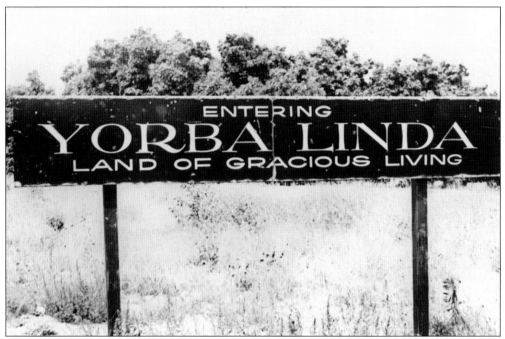

The Yorba Linda sign, seen here in 1940, announced to all the farm community's aspirations. (Courtesy of First American Corporation.)

An attendant poses sharply for the 1950s opening of the General Petroleum gas station. (Courtesy of First American Corporation.)

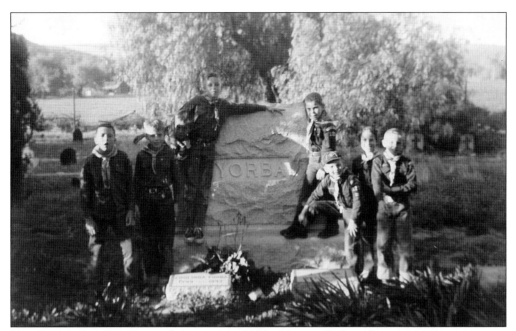

Boy Scouts visit Don Bernardo's grave in 1959, 16 years before the cemetery's restoration. Pictured here, from left to right, are Kurt Allan, Ricky Miller, Warren White, Jimmy Southwich, Joey De Shields, David Cromwell, Ronnie Shaw, and Mike Shepard. (Courtesy of Yorba Linda Public Library.)

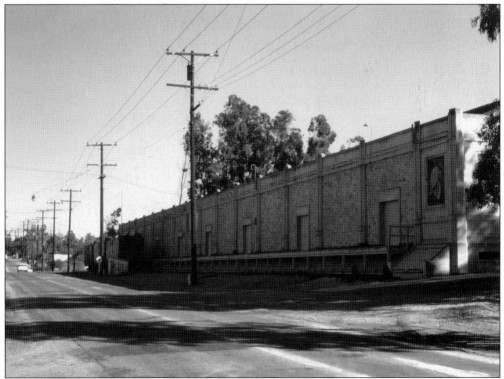

Seen here in November of 1961 is the Packing House. (Courtesy of Orange County Archives.)

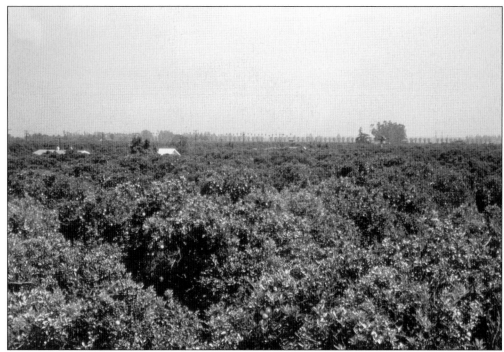

Here is a view of some of the older citrus groves in 1961. (Courtesy of Orange County Archives.)

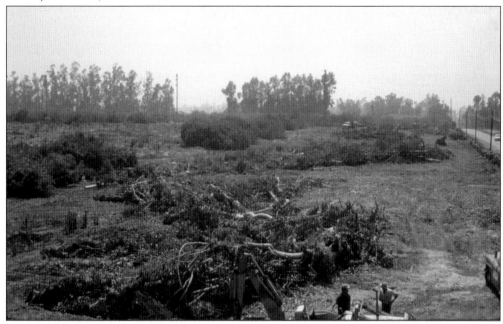

On the way to real citification in 1961, Yorba Linda's citrus groves began to give way to increasing residential development. The author remembers mountains of orangewood by the roadside in the 1970s, which supplied fuel for the annual Future Farmers of America pit barbecue in nearby Buena Park. Beef was seasoned, wrapped in burlap, and cooked underground overnight on the hot, fragrant orangewood. (Courtesy of Orange County Archives.)

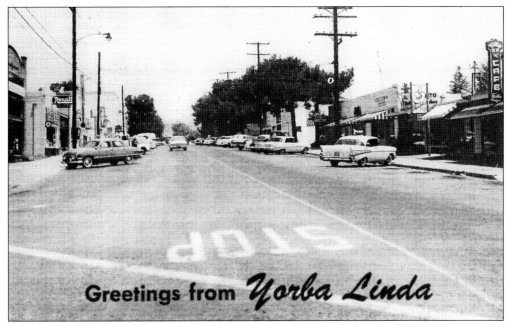

By the early 1960s, Main Street had acquired a more cosmopolitan look. This view looks north from Imperial Highway, with Turner's Cafe on the right. (Courtesy of First American Corporation.)

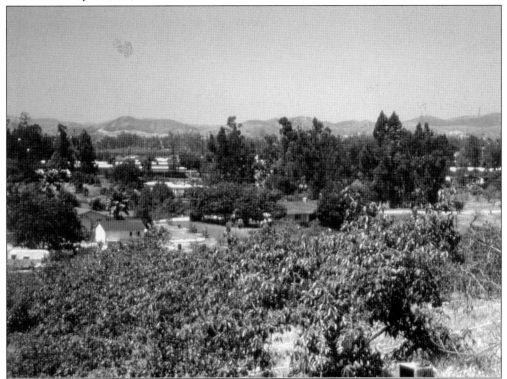

This is a downtown view of Yorba Linda as it appeared in 1961. (Courtesy of Orange County Archives.)

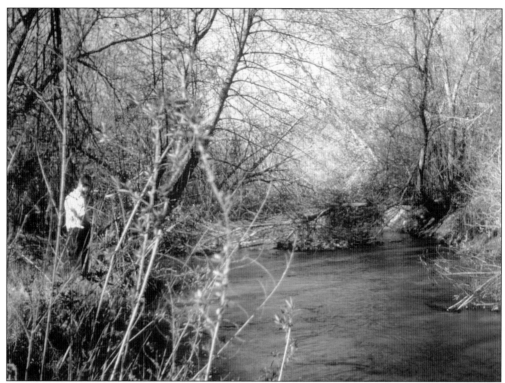

The Santa Ana River, in an idyllic scene from February 1961, bears little resemblance to the modernized, engineered channel it is today. The modern photo was taken from the jogging and bike path adjacent to Yorba Regional Park. (Courtesy of Orange County Archives.)

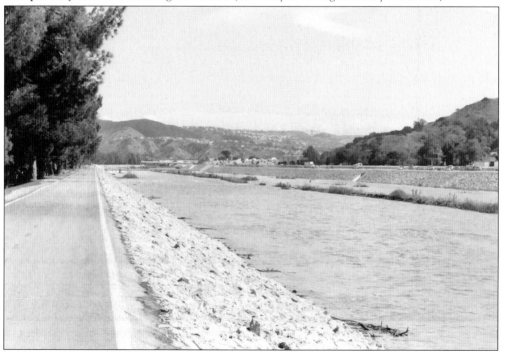

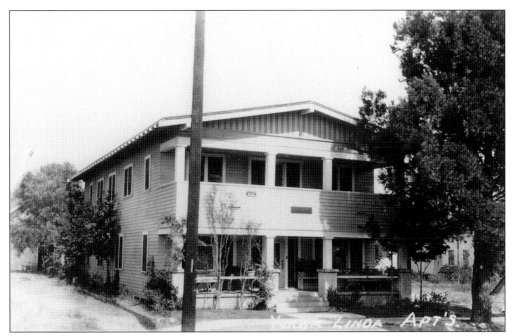

Yorba Linda's first apartments were located on Main Street. The building still stands. (Courtesy of First American Corporation.)

Seen here in 1965 is the Vons Market at Yorba Linda Boulevard and Rose Drive. (Courtesy of Orange County Archives.)

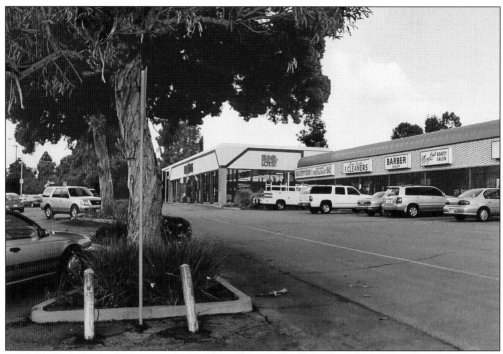

Today, the same shopping center contains a Big Lots in place of the Vons and many small businesses in the adjoining strip mall.

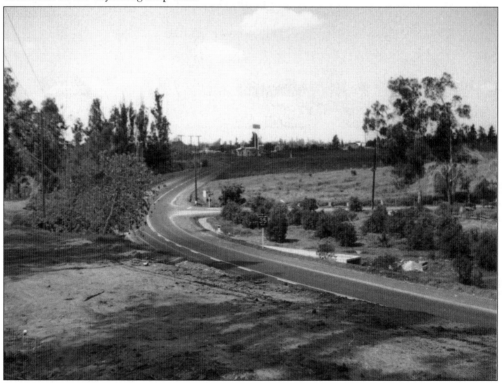

Yorba Linda Boulevard remained a rural route in 1966. (Courtesy of Orange County Archives.)

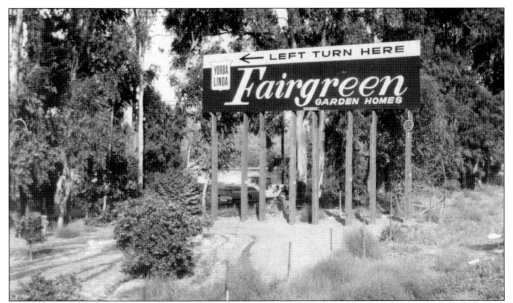

In 1964, the Fairgreen development sign sat among the eucalyptus windbreaks between citrus groves. (Courtesy of Orange County Archives.)

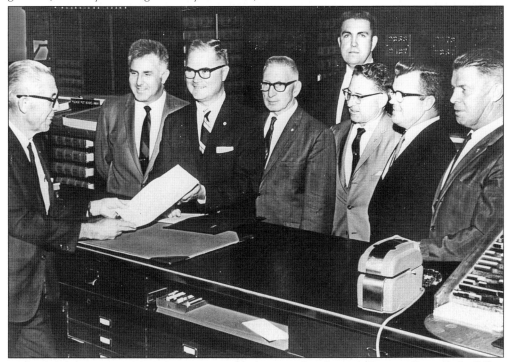

Yorba Linda's incorporation as a city took place in the Orange County Recorder's Office in Santa Ana on November 2, 1967. Pictured, from left to right, are Wylie Carlyle, county recorder; Roland Bigonger, attorney and mayor; W. E. St. John, county clerk; Burt Brooks, druggist and councilman; Jim Erickson, city attorney; Whit Cromwell, stocks and bonds expert and councilman; Bill Ross, representing the State of California; and Herb Warren of Marshburn farms, also a councilman. (Courtesy of First American Corporation.)

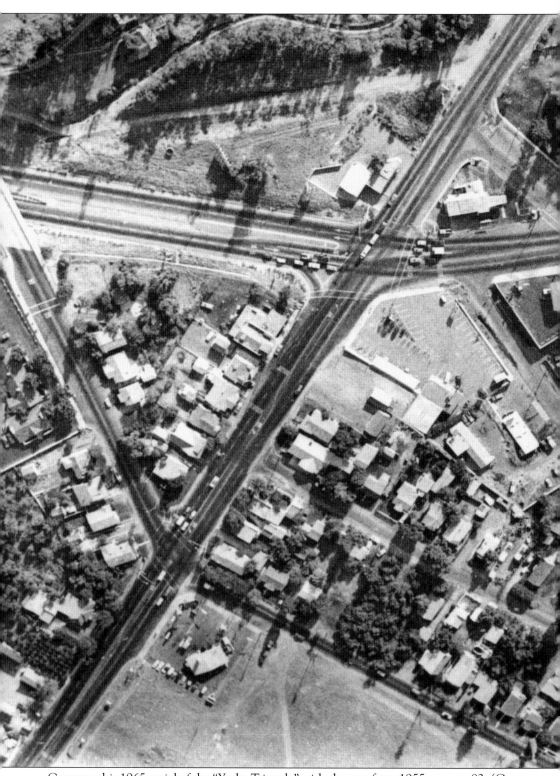

Compare this 1965 aerial of the "Yorba Triangle" with the one from 1955 on page 82. (Courtesy

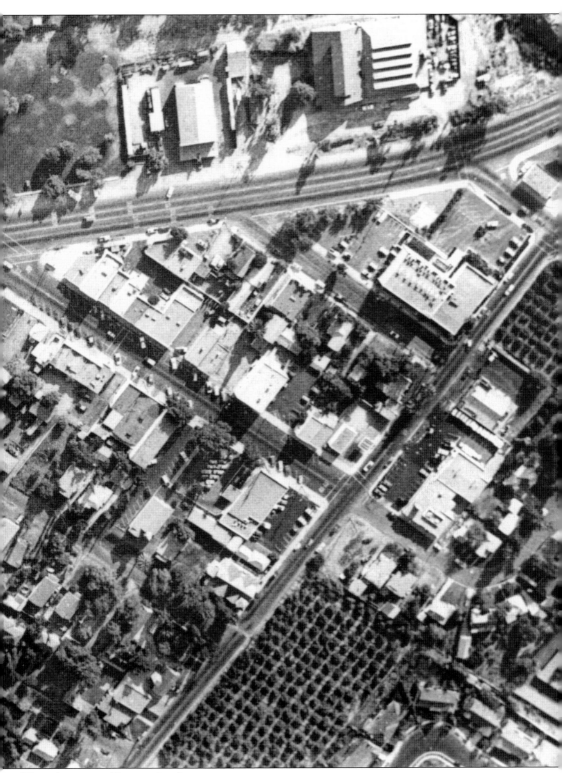

of First American Corporation.)

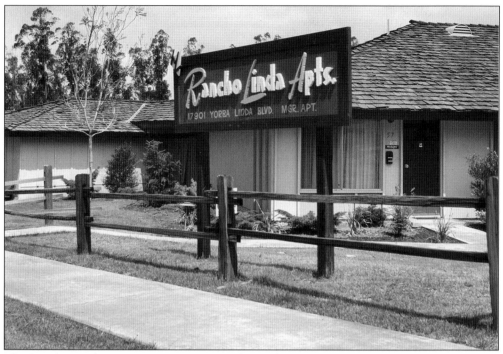

The Rancho Linda Apartments at 17901 Yorba Linda Boulevard are seen here in 1966. Today, the site is obscured by foliage. (Courtesy of Orange County Archives.)

A rustic scene from 1964 shows a bit of Yorba Linda's country ambiance. (Courtesy of Orange County Archives.)

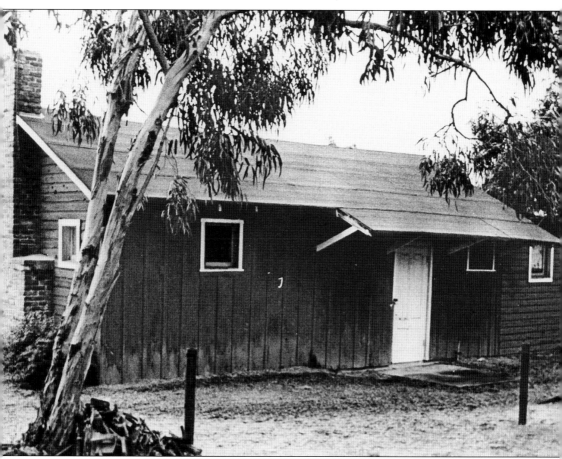

Yorba Linda was home to the "oldest boy scout house west of the Mississippi." (Courtesy of First American Corporation.)

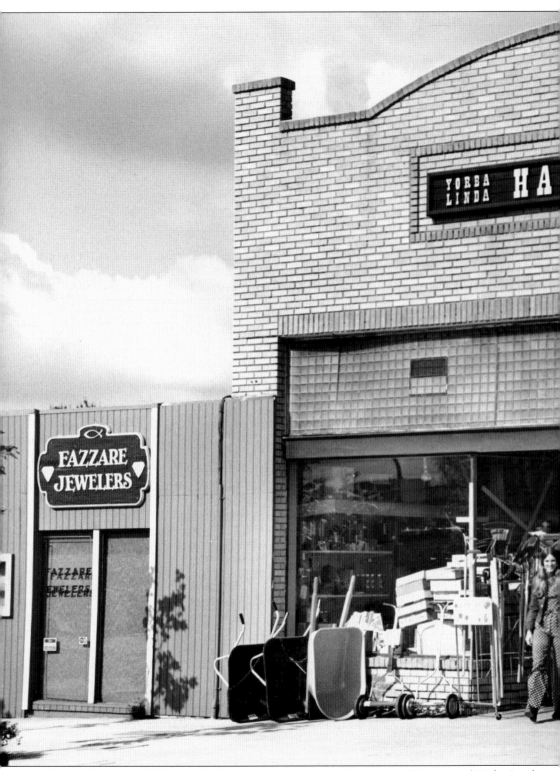

Depicted here in 1977 is the Yorba Linda Hardware in downtown. (Courtesy of Yorba Linda

Public Library.)

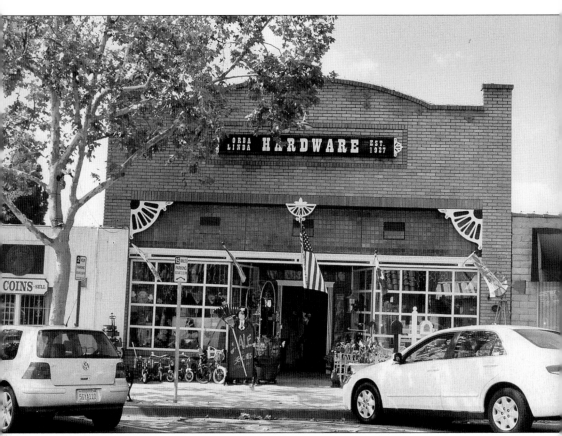

Today, the hardware store features an attractive sidewalk display of toys and lawn ornaments.

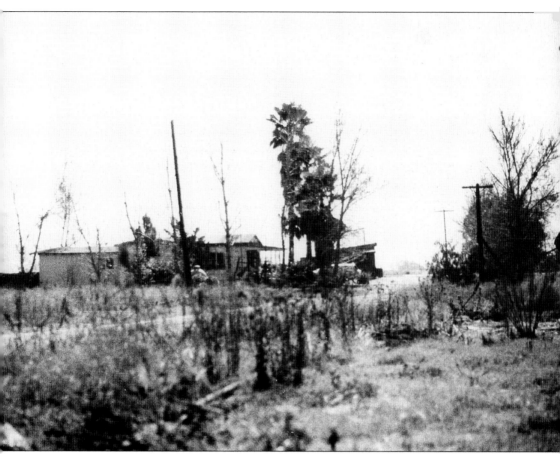

As late as 1981, Yorba Linda Boulevard and Buena Vista had been mostly rural. (Courtesy of First American Corporation.)

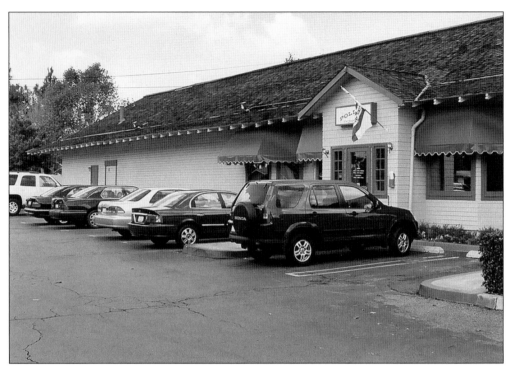

Polly's Pies was once the Yorba Linda Railroad Depot. Compare this view with the earlier one from the 1950s. The roofline is the 1912 structure's most identifiable feature. (Courtesy of First American Corporation.)

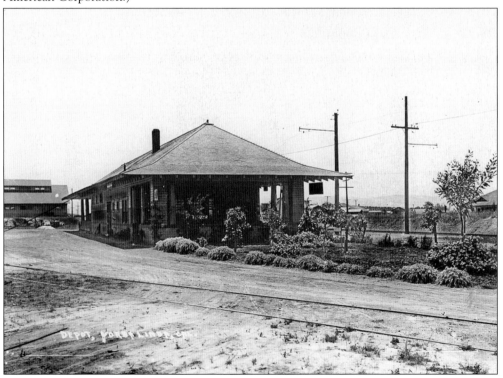

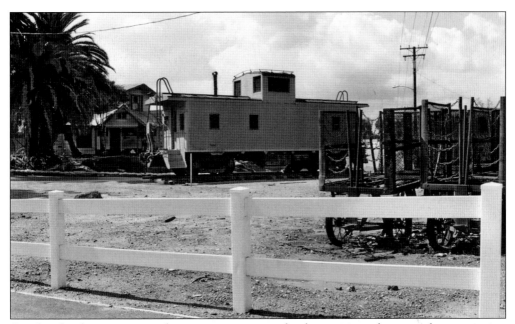

A railcar has been set up on the site in preparation for the anticipated master plan renovation of the area, which will include an establishment called the Caboose.

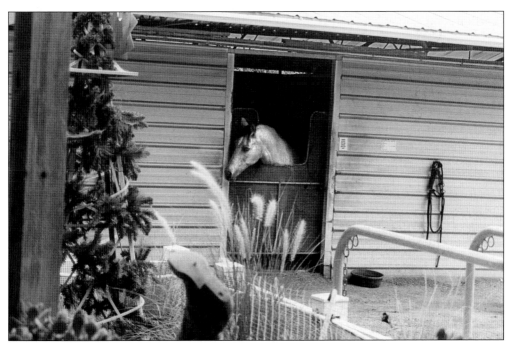

The Rocking T Ranch, located on Lakeview Avenue, still belongs to descendants of the original farming family fostered by Herbert Anderson and Mary Quirk, who settled here in 1916 and planted avocados. Their grandson, Jim Tice, now operates a horse ranch and equestrian training center on the ol' homestead.

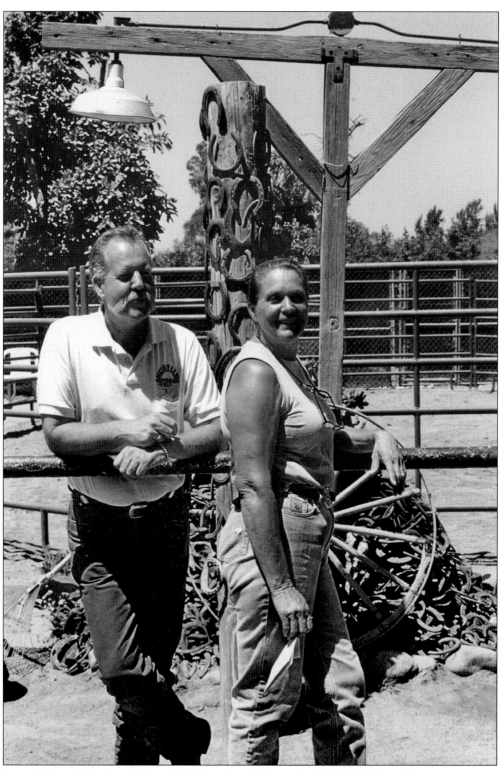

Jim and Carol Tice pose in front of "Horseshoe Hill" at the Rocking T Ranch.

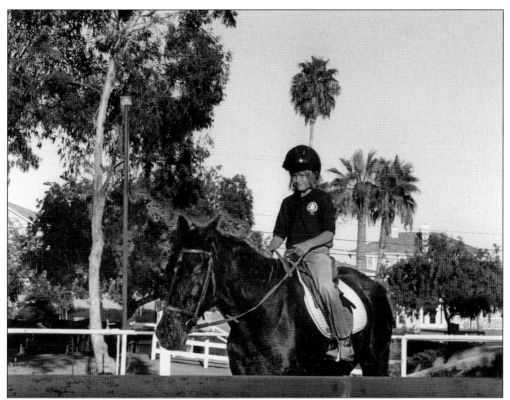

The Rocking T is primarily an educational facility. Here, some young equestrians take their riding lessons after school. Parents often pass time in the shady picnic area, safe from the bustle of kids, horses, and assorted frantic chickens.

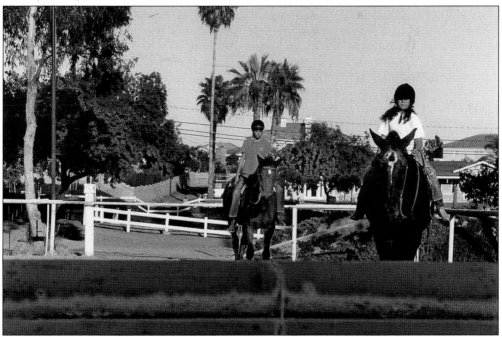

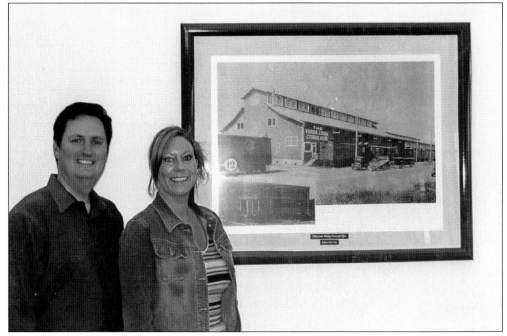

David and Patty Newell, of Newell Insurance, operate one of the many businesses housed in the old Packing House. They pose here in front of an early photograph of the structure. Historic photos line the walls in the hallways.

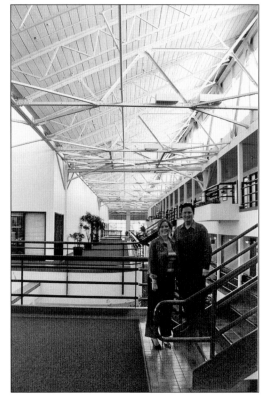

As can be seen in this interior view of the Packing House, the modern renovation has retained the building's "bones" while creating upscale offices for businesses catering to the medical, research, travel, insurance, and other fields.

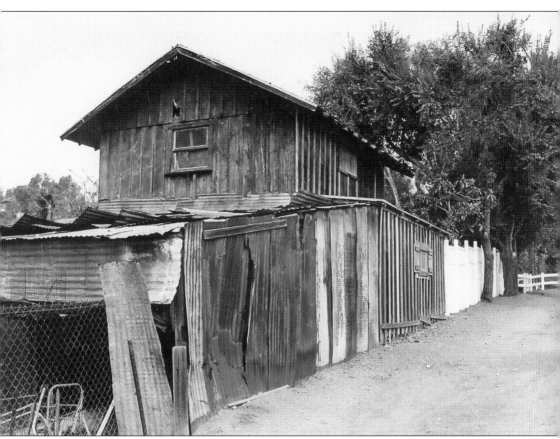

This old barn, built *c*. 1912, is located behind the Robertson residence on Oriente Avenue.

The Robertsons' plan, at publication time, was to restore the barn to prevent any further deterioration.

108

Little is known about the structure, other than it was never part of the home at this address—a long-lost photo showed the barn standing alone, against a backdrop of fields.

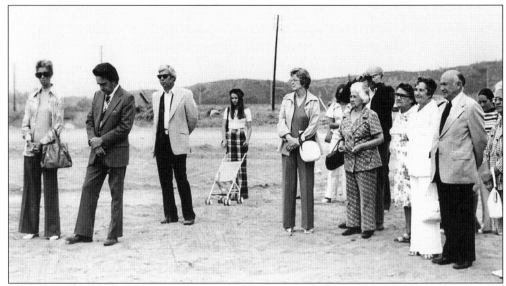
Citizens gather in Yorba Cemetery for the groundbreaking of Woodgate Park on July 14, 1975. (Courtesy of Orange County Archives.)

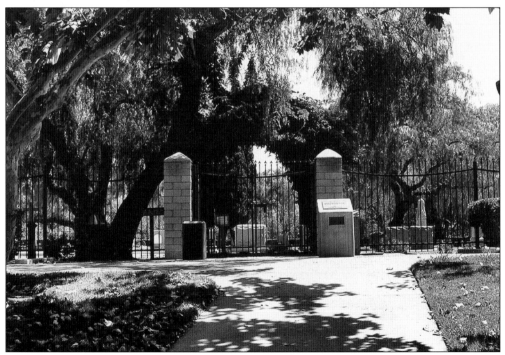
Here stand the Yorba Cemetery gates in Woodgate Park today.

Seen here is Yorba Regional Park soon after its opening in 1976. It occupies a swath of land over one mile long at the edge of the Santa Ana River. Although separated from Yorba Linda proper by a thin strip of Anaheim, the park occupies former Don Bernardo ranchland.

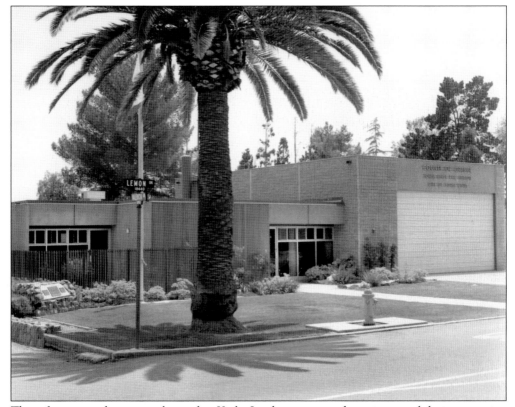

Three fire station houses are located in Yorba Linda to protect the citizens and their properties. The Orange County Fire Department fights home fires, brush fires, and other natural disasters throughout the region. This is the Old Town station as seen in 1971.

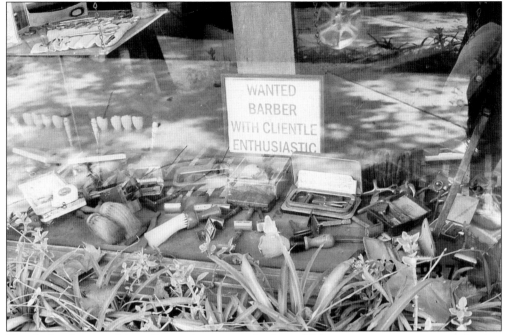

The barbershop on Main Street downtown displays old haircutting equipment and other paraphernalia in keeping with an Old Town theme.

Dr. Richard Cochran, Yorba Linda's first doctor, resided and practiced in this house at 4802 Olinda Street. The house still stands as a private residence. Today, Doc Cochran's medical equipment is displayed in the bathroom of the Bixby-Bryant Ranch House.

The Classic Cruisers of North Orange County began meeting at the local Carl's Jr. in 1993 and now meet at the Yorba Linda Community Center. Here, they gather at Yorba Linda's Featherly Park in 1996 for their annual Canyon Cruise car show.

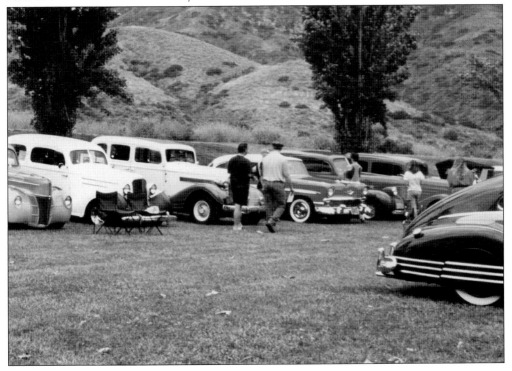

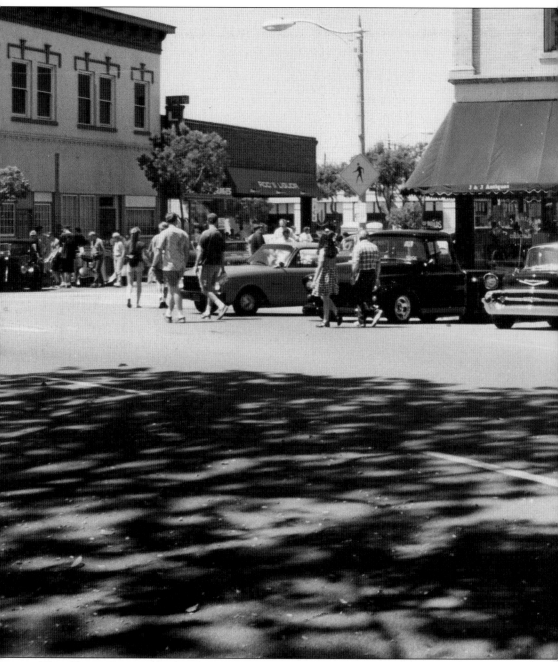

The Classic Cruisers display their cars at an old Orange County landmark, Orange Plaza, in 1995. All proceeds from their events benefit the Orangewood Children's Home and Canyon Acres Children's Services.

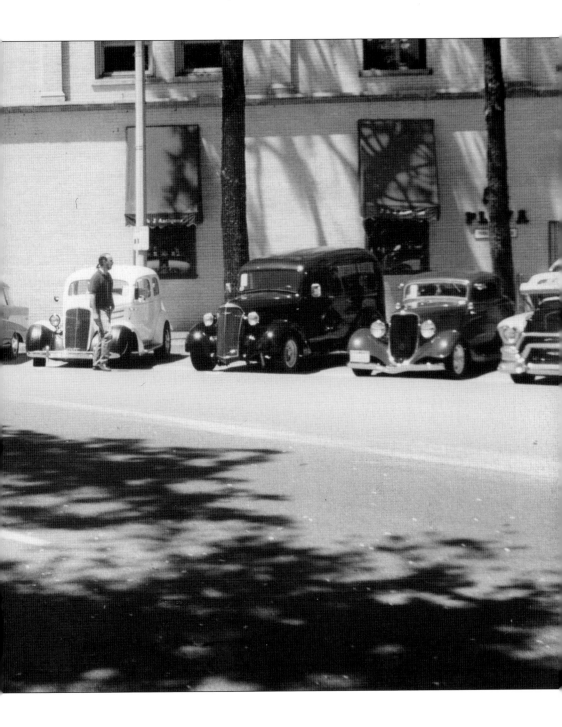

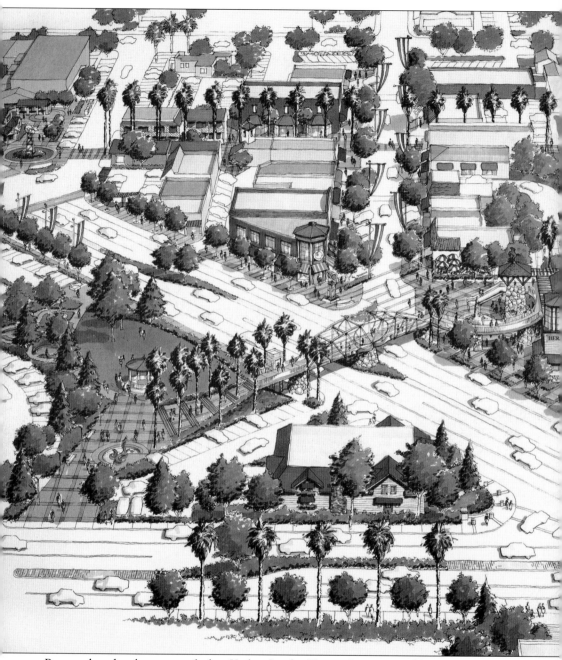

Proposed redevelopment of the Yorba Linda Town Center would renovate the retail complex and immediate areas—both commercial and residential—around historic Old Town. This artist's aerial rendering shows how the familiar Yorba Linda triangle would look after

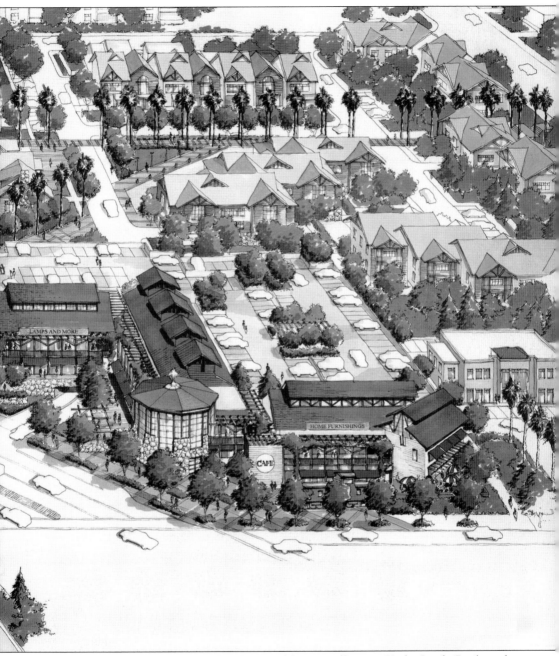

renovation, featuring a pedestrian bridge that would eventually cross Yorba Linda Boulevard. The master plan was adopted in September 2003. (Courtesy the City of Yorba Linda.)

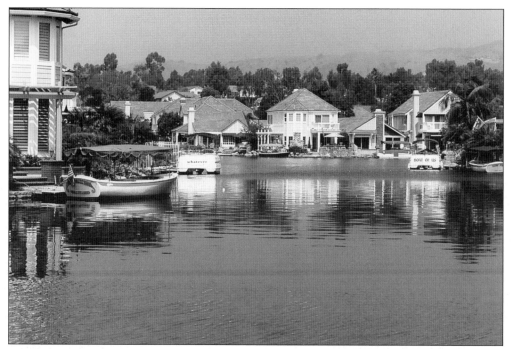

East Lake Village is a remarkable upscale development built around a winding lake. The community has a Venetian aspect with its many residential docks and family boats. It also boasts its own community website and many recreational amenities.

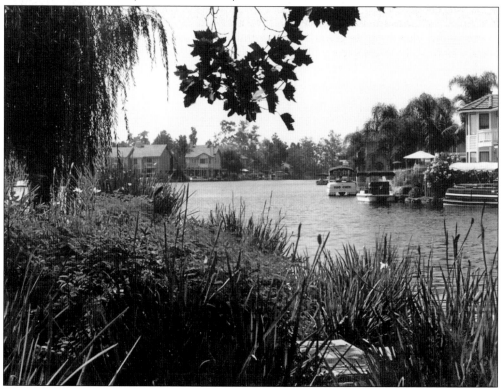

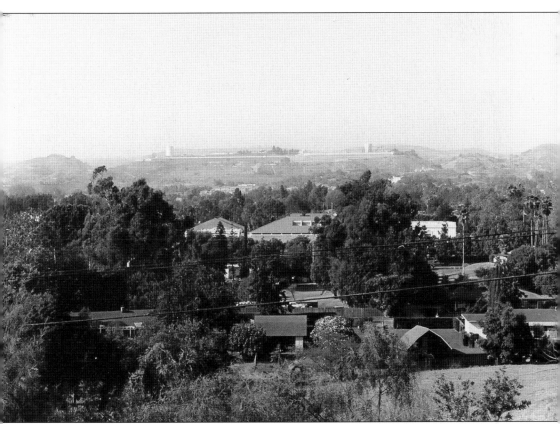

Compare this view from Reservoir Hill with the one on page 22. Gone is the wide farming plain, which has been completely filled in by houses and trees.

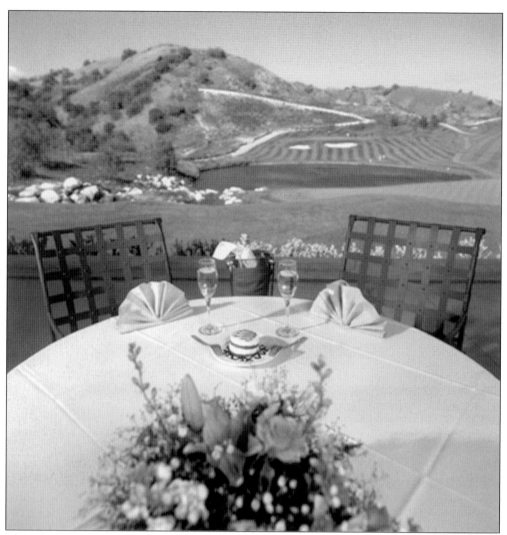

The Black Gold Golf Club, named for its location on the old Shell oilfield, is the newest recreational facility in Yorba Linda. It will eventually become the focal point of the Vista Del Verde master-planned community, with 2,000 homes, two parks, and an elementary school. (Courtesy of Black Gold Golf Club.)

Vice President and Mrs. Dick Cheney's helicopter arrived at the Yorba Linda Civic Center for a visit in 2002. The Cheneys attended a luncheon at the Nixon Library where they were presented with the Architects of Peace Award by Julie Nixon Eisenhower. (Courtesy the City of Yorba Linda.)

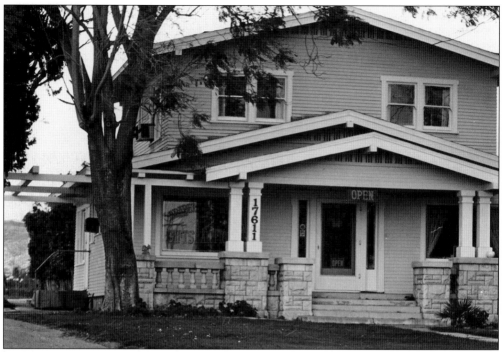

Arabella Smith's Gifts and Antiques, seen here in 1980, was formerly the Niswander residence. (Courtesy of Yorba Linda Public Library.)

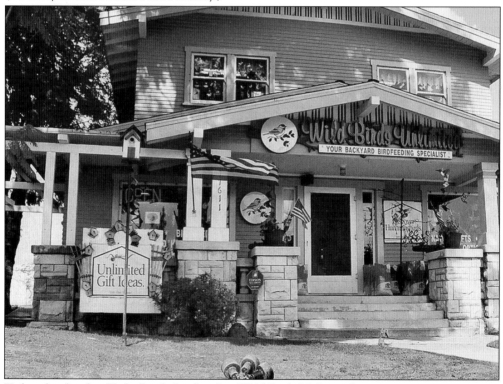

Today, this familiar Yorba Linda landmark is Wild Birds Unlimited.

A 1969 note sale poster describes construction of the third (sequential, not cumulative) Yorba Linda Friends Church. It was completed in 1970. (Courtesy of Friends Church.)

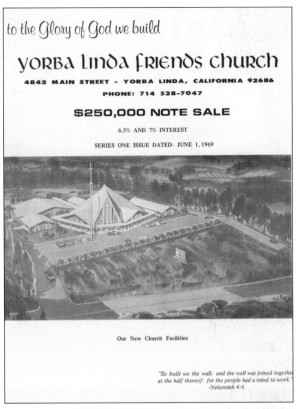

Compare this Main Street business scene with the 1952 view of the same location on page 56. Turner's Cafe and Robin's Market are long gone, and the former site of the appliance store now houses a restaurant and barbershop.

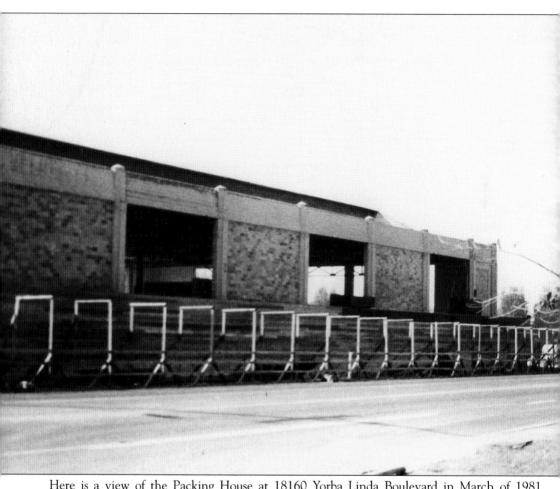

Here is a view of the Packing House at 18160 Yorba Linda Boulevard in March of 1981.
(Courtesy of First American Corp.)

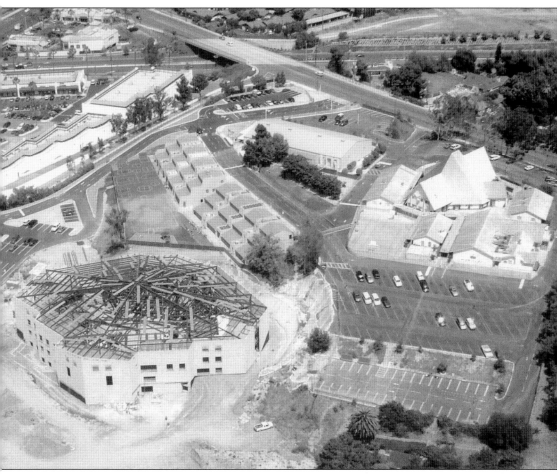

This July 2004 aerial shows the fourth home of the Friends Church under construction. (Courtesy of Friends Church.)

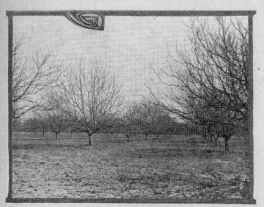
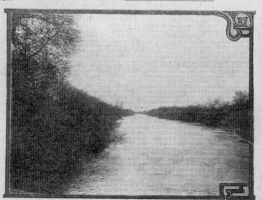
This Janss Investment Company poster stressed the benefits of farming oranges and many other crops in Yorba Linda. The possibilities were limitless.

BIBLIOGRAPHY

Butz, March. *Yorba Linda, Its History* (second edition). Covina, CA: Taylor Publishers Co., 1979.

Cleland, Robert Glass. *Cattle on a Thousand Hills: Southern California 1850–1880*. San Marino, CA: Huntington Library Press, 1990.

Erickson, Mary Ruth, and James V. Granitto and Shakunthalas Rajan. *The Yorba Legacy* (second edition). Yorba Linda, CA: Yorba Linda Public Library, 2000.

Hansen, Art, and Gary Shumway, editors. Fullerton, California: California State University, Fullerton, Oral History Program, Oral & Public History Center, Pollak Library, 1969–2005 and continuing.

Nixon, Richard M. *RN: The Memoirs of Richard Nixon*. New York: Grosset & Dunlap, 1975.